HOME KIDS

HOME KIDS

Evelyn Stamp

ISIS
LARGE PRINT
Oxford

Copyright © Evelyn Stemp, 2003

First published in Great Britain 2003
by
The Book Guild Ltd

Published in Large Print 2004 by ISIS Publishing Ltd,
7 Centremead, Osney Mead, Oxford OX2 0ES
by arrangement with
The Book Guild Ltd

British Library Cataloguing in Publication Data
Stemp, Evelyn, 1938–
 Home kids . – Large print ed. –
 (Isis reminiscence series)
 1. Stemp, Evelyn, 1938–
 2. Children – Institutional care – Great Britain
 3. Adopted children – Great Britain – Biography
 4. Abused children – Great Britain – Biography
 5. Large type books
 I. Title
 362.7'3'092

ISBN 0–7531–9972–6 (hb)
ISBN 0–7531–9973–4 (pb)

Printed and bound by Antony Rowe, Chippenham

INTRODUCTION

I was born in High Wycombe, not at 460 London Road as my sisters were, but in hospital. It must have been New Year's Eve, as my birthday was given as 1/1/38, hence the name Eve. I'm told no-one realised that my birth mother was having a baby.

When we three sisters were aged five and a half, four and two, our mother died. My older sister Edith and myself were sent to a children's home at Bledlow Ridge in the Chilterns, but Jean, the youngest of us all at the tender age of two, was taken from everyone she knew to a home at Beaconsfield. We were so young and didn't know then that we wouldn't see her for three more years to come. It's hard to describe what that experience did to us all.

We never met our real father. Later on in my life, I could have done but as it had been just us three for 34 years, I felt only hate for him. We learned later that he had put us in the home, remarried and had three more little girls. I know I did the right thing not wanting to see him ever. As my story unfolds it will become quite clear.

Many things were to happen to us — good and bad. Meeting up with a family we didn't know we had after all those years ended up in total disaster. When there

were just the three of us, we were strong; when others were involved, we were the weakest. I feel it is up to each person to transform their life into what they feel in their heart it should be and that's what I did, but that was not to be for many, many years to come.

The greatest gift life has given me are my two children. The lost, lonely and terror years are gone, and with the love put into my heart by two unselfish and wonderful foster parents, my children had a loving happy childhood. My years are now filled with kindness and love from my family. I am indeed a lucky person, but I have a need to write this book.

Evelyn Stemp
28 January 1993

CHAPTER
ONE

My sister Edie told me about many things that had happened to us, such as when we used to be given pennies to go to the little shop. She can remember this quite clearly; we were only very small. She could remember me falling into some water at the bottom of the garden and being pulled out by men in big boots. She said I had been very ill as a small girl and also that our sister Jean had to be taken to the hospital up the hill. One thing which stuck in my mind involved two brothers and four sisters, and that we never slept upstairs, but in a room down at the front of the house. Later on in our stories Edie would insist that it was true. How right she was! Unfolding in my little head were all those things that had been unexplained for so long. My sister opened up the truth that other people wouldn't talk about; the water running to the mill, the long grass, big black boots, oh so many things going around in two little girls' minds. How was it that Jean had a scar all round the tip of her third finger? Always in our minds we were aware that things were being kept from us. "One day you will see, Evie," Edie would say to me. This was only the beginning of the things we had to know.

So it was that our mother had died and father couldn't face taking all the responsibility of three small girls. Of course, we didn't know any of this at the time, but can remember people being around the house we lived in. There was a lot of chatter, but to this day I can't remember who these people were. I can only say they must have been the family that we would find out about later, in our adult lives. I can truthfully say that I don't remember our father's face and I can't remember my birth mother at all. I feel now that she must have been very ill, perhaps she had already died, but all of us being so little we didn't understand any of it then.

I don't say, or even feel, that it could have been easy to make the next decision, or who made it, for we shall never know the whole truth about what happened next. Jean was taken away. I don't remember faces, only hands. Jean was screaming. She was only two years old. She must have been terrified of these strange people dragging her away from the only warmth she knew.

So here we were, Edie and I, not even remembering the journey that was to take us to our destination. Somehow, I can remember one part of that road, big hilly sides, so white, we didn't know they were the Chiltern Hills. We had never gone any further than the corner shop just down the road from the house where we lived. The small car fitted the small lady who was driving it, not that we had ever seen a car before, any more than we knew where we were going. This lady just kept talking, I can remember that, but the words didn't mean a thing to us. Perhaps she knew just how confused we really felt. We were being taken

4

somewhere, by someone we didn't even know and there wasn't anyone that could do anything about it. The road stretched far ahead of us and we seemed to go on and on. I don't think that even having Edie with me could have taken the upset feeling away that day. My sister must have felt the same, but we never spoke a word, we were too scared. Why were we here at all? This funny feeling inside me, what was it? When would it go away?

It's often a good thing none of us knows what is in store. During the car ride we had been told one thing that I must have remembered; mummy had died and there was nobody else to have us, so we were going away from that place to somewhere called Bledlow Ridge Home. This we couldn't really have understood, being so small. The lady driver said her name was Miss Tunley and she was, we were to learn later, the person who would be dealing with us through most of our young life. We arrived outside these big metal gates, so high, they were black and locked on the inside. A man came out of a small hut from the right of us, Miss Tunley spoke to him and he unlocked the gates and we were ushered inside.

In front of us was a wide pathway, which led up to a large house. This is where my mind goes slightly blank. Trees, hollyhocks, cornflowers pink and blue, and wild strawberries now take over my mind. I think that this part of it all, the blankness, will never come back to me. It's as if there is a space left, and then I can remember things starting to happen to me again. We walked up the pathway together, Miss Tunley making it all

happen, as I'm sure it wasn't by choice that we continued walking. Next we were in the house, the hallway was big and to the left-hand side was a room with talking going on, quite a lot of noise.

A lady, round-bodied, round-faced, with white hair which curled round at the back of her head, stood there. We were told this was Miss Peplow, the Matron of the home. She didn't smile, but just talked to Miss Tunley. I don't remember Miss Tunley leaving. We were in the hands of this other lady now and my tummy was still upset and feeling strange. It must have been late afternoon. Now I think about it, the room on the left was hustle and bustle, long tables end to end, two lines of these. Some other children and grown-ups, just a few, were getting food, bread it was, out of a big long tin and putting it onto plates. I think it must have been time for the children to eat and we were made to sit down at one of these tables. The bread was already spread with something but, whatever it was, we ate it. If anyone wanted more these big girls just opened up the big tin and hands that were held high got fed. We didn't say a word, just sat where we were. If you weren't told anything about what was going to happen, you couldn't ask. This was to be our way of life from now on, but we didn't know it yet. We would soon learn. I thank God for my sister being with me. Poor little Jean was all on her own.

CHAPTER
TWO

It was bedtime, and they said the big girls took charge of this. I must tell you that years later I found out these girls had been put into the home years before and they knew nothing other than what they were trained to be — exactly that, training girls. You did what they said, when they said, and you didn't dare ask why. There were no ifs or buts. We were never told this at the beginning, we just knew it and you remembered it.

As I followed the other children up the stairs, the big girl was telling us all that we must keep in line as we followed her into a room containing several baths. We had to undress and wait our turn to have a bath. There was more than one training girl in the room and they just pulled the next child to be bathed towards them. All the time children were crying, some were screaming, and some just stared at what was going on in disbelief. My sister and I were in the last group. When a child was bathed, he or she was made to sit against the bathroom wall singing "Oh Danny boy", and to this day I can't stay in a room where this is played or sung by anyone. The tears come and I can't control my upset feeling, so I just leave the room until it's over. The big girls would get bathtime over as soon

as they could, it didn't matter to them if your head went under the water. I wondered why so many little faces came up gasping, shocked, then screaming. It was the most awful feeling that they wouldn't let me come up. It terrified me but they seemed to enjoy it, and I say this for sure because here I was to meet with the most wicked person I ever encountered in my entire life. She was a training girl, or rather a person I now realise needed some kind of treatment herself. How could Miss Peplow not have seen it for herself? This girl, responsible for children who had to rely on her for everything, was sick in her own mind. I will describe her more fully later.

Bathtime was over and we were put into nighties. One by one we followed each other onto a landing then into a long dormitory. There were many beds in there, more than I had ever seen before. The children got into some of the beds, others were put into them. I can remember I was put into a bed on the right but I was looking all the time for my sister. Where was she? Looking across the room I saw Edie on the other side of this big room. Her bed was right next to one of the windows at the far end, I was about four beds along on the other side, away from her. Everyone was lying down, no noise, so I did the same.

The training girls had left the dormitory now, not a sound from anyone, still. One of the big girls came back into the room and said loudly that she would be back in half an hour, and anyone that wasn't asleep would get the brush. I wondered what she meant, it didn't mean a thing to me, and I'm sure my sister was just as puzzled.

I lay there but I couldn't go to sleep, I tried but I couldn't. I could hear little noises now, some were upset, not loud, and I could hear little coughs coming from other beds, but I didn't look, I didn't dare. Some time had passed and footsteps came into the room, it was the training girl. She was moving from bed to bed checking who was still awake. I didn't move, just peeked with one eye. She must have found someone awake. She pulled back the covers and in her hand was a wooden bristle brush — this was what she had meant. She beat this girl with it on her bottom, the little girl screamed and she moved on to the next one that was still awake. I just kept my eyes closed so tight and tried not to breathe, but she must have realised who was asleep and who wasn't. This was to be one of many nights when I can remember the pain as she brought the brush down on my skin. Then she moved on — not a word was spoken by her to anyone.

It was dark but with the light from outside the window I could see my sister's bed. I was scared, and I felt if I could get to the other side of the room I would be all right. I still don't know how I got the courage but I did. I found myself at the side of Edie's bed and just crept in beside her. She moved, looked at me and we held on to one another. I made sure that I had made it back to my own bed before I was seen by the training girl. Not every night but most times I sought the comfort of my sister. Words never passed between us about this, but at the time I knew she understood because she loved me.

First thing in the morning we could hear a lot of movement. It was strange for me to understand, we had never been used to any of this at 460 London Road, where we used to live. All the children were washing — "hands and faces" as they called it — and getting dressed; that wasn't any trouble for them as they knew what they were doing and already had clothes to put on anyway. For Edie and myself, we still had the things we had arrived in, but I'm not sure where these clothes were as since our bathtime we had not needed them.

I can't remember what we wore as we were taken downstairs that morning, but all the other children were dressed in identical clothes; black pinafores, blouse, black socks, black shoes. When we were all seated at the two long tables, I realised that the boys must have slept in another dormitory but every child was ready waiting for breakfast, boys and girls together. The training girls were coming round with big open tins. Inside was bread which had already been buttered. It didn't taste very nice but we were hungry so we ate. Porridge was given to us — this was something Edie and I had never tasted before, but that was the name it was given. It was white, weak and very runny with lumps in it, but we were so glad to have it, as I'm sure we couldn't have been very well fed where we used to live. We had jam on the bread, that was nice, and once the breakfast was over all the bowls and plates had to be put together and passed to the end of the table.

Miss Tunley appeared and told Edie and myself to follow her, and we went from the house back towards the iron gates we had come through the day before.

That upset feeling came back and I can remember holding on tight to my sister, not knowing what was going to happen to us. We didn't go through the gates but to the left of them. Inside was the man we had seen before. There were shelves with lots of clothes on them. Miss Tunley selected knickers, vests, socks and tunics, also black shoes for us both. I couldn't believe they were for us. Once we were dressed, our other clothes were put aside. We looked like all the others. We were now what was known as "Home Kids". We went back to the house not knowing what would come next.

I can remember playing in the grounds of the home. There were apple trees and I can still see the pink and blue of the cornflowers just outside the window. How they grew I don't really know, they seemed to be stood in gravel, but they are one of my favourite flowers. It must have been a Saturday that we had arrived because a day or so later, after the usual time to get up and dressed, we had breakfast and then lined up all in black macs and berets, and holding hands two by two we started along the gravel path towards the big gates. They were unlocked to let us pass. This was the first we were to know of the outside world and of Bledlow School. The road was very long indeed, small and winding. The training girl kept a check on everyone as we made our way along. The strange thing is I can remember all this, yet I can't remember one face of any of the children I went to school with or any that I lived with in the home, only my sister. There are so many other things I do remember and wish I could forget,

but as I am writing this, I realise even more that I never will.

The school was very small. The front of it was peaked, with railings all around to keep us safe as it was right on the main road. The classroom was full of little desks with lift-up lids. I can honestly say I was happy there. I remember cutting out coloured sticky paper with tiny scissors. The teacher was stern but kind to us. I never minded being there with her, but out in the playground was a very different thing. The children from the village wouldn't have anything to do with us and were very unkind. They gave us the name "Home Kids". That is indeed what we were, but we never were allowed to forget it. I hated that name and would never admit it to anyone as I grew up, rather working around it if I was asked about myself.

CHAPTER
THREE

In Bledlow Ridge Home, one day was pretty much like the others. We didn't really know days as such, well I didn't. The only thing that made me realise something was different was what happened on one certain day; I got to know it as Saturday. Lots of children would run to the window, the one that faced the gravel path, and they would press their faces right into the glass, always looking and looking. It seemed that it went on for ages. Then one by one people, grown-ups, would arrive. I can't remember much about them, but they carried brown paper parcels with string holding them tidy. As they came inside the home different children would run towards the door. Next thing I could see them walking down the path together. This seemed to happen on every day that was called Saturday, though sometimes they didn't come at all.

I must have been told that these were these children's families, though I can't remember ever asking any questions about these visits. I must admit in my own mind, as Edie and I would stand by the window, and I was always thinking why doesn't anyone come for us? We never understood this. I always

thought that next time someone would come for us with a brown parcel, but they never did.

I'm glad we never knew at the time that there were people out there who just didn't want to know us. We were out of sight, and that's the way they wanted it. Little did they know that one little girl wasn't going to let it stop at that, even though she didn't know it at that time. This is the way I have always felt. When there were just the three of us, we were strong; when there were more we were the weakest. This is one of my feelings that would one day prove to be be so true, but that day was a long way off.

CHAPTER
FOUR

It was Sunday, so we all went to church. Bledlow church was very small but it was very nice inside. Everyone went, I think it was so close to the home that it never took us long to get there. I can remember where I used to sit, always to the right-hand side quite near the front. It's funny but that memory is so clear in my mind. After that we would go for long walks, once dinner was over, always having to hold hands wherever we went. We must have stood out to everyone in the village. No wonder the children in the village always called us that name, we must have been a strange sight for anyone who had a normal home life with a mum and dad. Perhaps they thought we had been very bad and that's why we were in the home. I know at a very early age I promised myself that one day when I was older I would have lots of friends. That I would make sure of!

The Sunday walks were lovely. I can remember all the children used to enjoy themselves. At this point I must say that I seem to remember things that brought happiness most strongly — they are not the only things I can remember, but the strongest. Lots and lots of steps we used to climb. They seemed so large that each

wooden step into the hills seemed quite a challenge to me. How thirsty we all used to feel. Some of our Sunday walks took us to where wild strawberries were growing, the creepers growing upwards onto the hill. The tiny wild strawberries tasted so sweet, they were wonderful. Eating them was a real treat. I can't tell you where the hills were — I can only think it was the Chiltern Hills, but near to Bledlow that's for sure. It was then time for us to make our way back, not hand in hand like every other day but running and happy, seeing who could get the first drink of water when we got back to the home. This tasted so good, I felt as though I would never stop drinking, I was so hot and happy.

Suddenly, my Sundays changed and also my life, from something that was stressful to utter despair. We had all got ready for church one Sunday and were waiting to go, when one training girl came to me and said she was taking me for a walk after church. Being used to doing what I was told, I had no reason to mind. I would be going out, that must be nice. Her name was Vera, I shall never forget that. She had long black hair and a very thin face. I had seen her in the home before, she had a brother there who did jobs around the home, something to do with the water pipes. He was strange. He used to eat vaseline out of small flat tins and then give the tins to the children when they asked for them. I think this Vera and her brother had been put into the home when they were very young like me, because they had always been there, it seemed to me.

Church service was over, but I didn't go with the other children as I normally did. This girl Vera came towards me and said, "We are off for a walk." That seemed all right by the adults that were there, so off I went with her for my walk. We got to the bridge, the one we always passed on our way to the school, but instead of walking on, she stopped and looked at the small stream to our left. It was very shallow, I could see the stones through the water. Her face came down close to mine.

"Get on my back," she told me. Her face looked mean, I felt very afraid. "Get on," she said, in a very nasty tone. As she spoke she bent down. I did what I was told. As she stepped down the slope onto the first stone, she said, "Don't you dare get your feet or one bit of mud on my mac or you will be for it."

I can't explain what her voice sounded like. I felt very upset and tried so hard to keep my legs away from her body. She continued to step her way along the stones, but it was so hard — my legs moved, I felt my feet touch her several times, I was so scared of her.

She continued around the back of the trees, around the rail of the small bridge. It seemed to me that we were going away from the road that we had started from. Indeed we were. The stream led us behind all the houses at the back of Bledlow School. Vera got out of the stream onto a waste piece of land with me still on her back. I was made to get off and she was hissing at me. Look what I had done! Her mac was marked with small bits of mud that had come off my shoes. I had to be punished, she said, for what I had done. Nettles

17

grew as high as me and I was grabbed and hurled into these, time and time again. I know I was crying for her to stop, my face and hands, my legs were stinging so much. It was awful. Because I was making such a fuss, she said I needed to be punished again. By this time I was shaking like mad, with a total fear of this person.

Next she broke off long sticks from a willow tree. I was still crying. I was made to sit on a bank with my knees up to my chin, head back. She whipped my knees with the willow. This would go on, she said, until I stopped crying. It was hard not to cry, but after a long time she stopped hitting me, grabbed my arm and said, "You tell anybody about this and it will get worse for you." My body was stinging so badly, I didn't know what to do with myself. Clumps of red rash were all over me. She made me get onto her back and we went back the way we had come, step by step on the stones, back towards the home. I was still crying, and she told me to shut up. As we got nearer to the home she bent down and said, "I'm going to bath you tonight, OK?" Again, her voice was horrid, as though she was mad with me. I was frightened to death of her and dreading bath time. I remember thinking, I can't tell anyone about this or she will find out — so I just kept it to myself. I realise now it was such a big thing for one so small to have to cope with alone. Even now, so long after, I think of the small children that are in that sort of position today, and it makes me sad.

We had tea and bath time arrived. I was feeling quite sick inside. Vera stood at the doorway of the dining room and made it quite clear to me she meant what she

had said on the walk earlier in the day. There was not a thing I could do. I dare not speak about what she had done to me. She must have known this and it must have been quite clear to her just how scared I was. I went upstairs with the others, but instead of going into the big bathroom as normal, she opened the door of another room. It was a long room, with one bath to the left and a window at the far end. She was filling the bath, and steam rose as she made me undress. I was made to step into the bath water. It was too hot, I couldn't stand still. I started to cry, trying to get out, away from the heat. She had made it hot, but not hot enough to scald my feet. "Open your mouth now," she said. A lump of soap was shoved into my mouth, and I was made to bite down onto it.

After a long time of this treatment, she let the water out and started to fill the bath with cold water. I got very cold but it was much better than what she had just done to me. She really was enjoying it, I don't know why and I don't think I shall ever know now. She told me to open my mouth and the soap was removed. My teeth were filled with soap, it tasted vile. I was then allowed to put on a nightie and was told to get rid of any soap in my mouth by cleaning my teeth. The nettle rash was still stinging and the water had made it worse, I think. My legs were so red. I was reminded that if I told anyone about this I would be in for it. I just wanted to get out of that room and into my bed. I lay there, and I was so upset the tears flowed, but no noise came out.

This treatment went on and on, and Sundays became a nightmare to me. I dreaded it but I knew that I couldn't do a thing about it or her. I stood by the bathroom window many times thinking bad thoughts, but I couldn't even tell my sister about any of it, not a thing.

I think this was when I changed. After such a long time of this sort of treatment and built-up fear, I felt that only I could help myself. Sundays came round so quickly now. What I used to enjoy had gone for me — thinking back on it now it seems so sad. Vera was there as we lined up for church that morning. My mind was blank as I went along with the children and sat in the church. So much came flooding into my mind. I know one thing for sure, I just felt I had to get free of this awful thing that was happening to me. I don't remember anyone or anything — I started to scream. I was in church and I didn't stop screaming. It didn't matter, I would be all right now. I can remember telling those people I had lots of pain in my tummy. The next thing I was taken away. I was picked up and put into a sort of van.

I found myself in a tiled room in hospital and that was it. When I woke up I was in a bed with cot sides. My tummy was held firm in pink sticky plaster — it covered all of my stomach, it was pink and wide. I don't know how long I was there. Eventually the nurse removed the wide tape, and I was given silver clips to keep in the cotton wool dressing. They had opened me up from my navel to the bottom of my stomach. I was

never told what they had thought about it all — I never had a pain in my tummy, but I did need help.

I went back to the home, but Vera never came near me again. I now have a scar that will never leave me but has faded slightly over the years. It can still remind me of the horror of Sundays but the safeness of the church. Who knows, perhaps even then I knew that God is love — He helped me, I feel sure of this. I wonder if Vera is still alive. I hope she can forgive herself. It's sad, but I cannot.

CHAPTER
FIVE

Things seemed to get better for us then. I can think back about the time of year they called Christmas. We were told that when morning came there would be stockings for us all with our names on, on the landing. We couldn't wait for this. On the big landing I can remember loads of things, and children tugging at these Christmas gifts looking for their name tag. These were not like the pillowcases of presents that the kiddies have today. Nuts and fruit, a small book or toy — it was great fun. Thinking about it, the people looking after us seemed different around this time. Someone had gone to a lot of thought and care to give us all a happy time. I realise now that not all of it was bad.

Another time of year that stays in my thoughts was the big bonfire that was built in the middle of the big field where we were allowed to play. This must have been November 5th, what we now call "bonfire night". Potatoes were put in to the fire and I can remember them being black but tasty to eat. We used to go scrumping the apples from the trees in the grounds, tuck them in our knicker legs and save them for later. If you got caught with them you would get a good hiding.

Edie and I got caught more than once. We were no different from any other children I suppose.

Red Cross parcels were sent to the home. Each one of us would be given one. Again a small bag of sweets, a small toy, little things but they seemed a lot to us. One time when the parcels came, I had sweets and a small purse. This other girl wanted the purse and I agreed, if I could have her sweets. We exchanged the purse and sweets. She then reported me to a training girl for taking her things. Miss Peplow was told and I knew I was in big trouble, even though I hadn't done anything wrong. Miss Peplow was so cross with me she wouldn't listen to anyone. I was told that I would go without tea and that I must sit on the stairs out of sight and not move. As it got darker and darker I moved my bottom down one more step, just so I could see the light coming under the door where the other children were. A voice shouted, "Get back up there!" I was always afraid of the dark, and this made it worse.

I know it is a strange thing for others to believe, but we didn't know a thing about the world outside the school we went to. We were given just one sweet a day which was after dinner, they were boiled sweets. Years later I would learn that newspapers existed, that dogs and cats lived with families. I like to think it was because we were still small, but I don't really think this is the case. It is strange how certain things stay with you always. Each Friday after dinner, every child had to line up down by the wash room and we were given a medicine called Mistellba, it was awful. Lots of children used to be sick with it but if that happened another

small capful was given to you. We were told this was to keep us well, but I now know that it was most likely to keep us regular.

Edie and I never spoke of Miss Tunley. She had brought us to this place but until she arrived again one day about three years later I think I must have forgotten her. She was there talking about us, we didn't know why. Miss Peplow came to fetch us to her office and there we were told to follow Miss Tunley as she walked towards the small shed on the left-hand side of the gates. Looking at the wooden shed brought back memories of the day we had arrived at the home, the fear of not knowing what was happening to us — now here it was again, that feeling of "what are they going to do to us now?" Small children worry more than many adults realise. It was as though we didn't need to be told and that was so wrong, it really was. My sister and I were not told a thing. The man inside the shed was being given orders by Miss Tunley and he was putting clothes, two piles of everything, on the counter. All the items were brand new. Other things were added, like dresses in pale pink and pale blue, they had tiny flowers over them. More clothes were packed. Miss Tunley then said we were going to stay with a Mrs Green and she would be taking us there right away.

We had no idea where this was. The only place we knew was the home where we had been since our mother had died. Everything was ready. We were told to put on our macs, so I know it must have been quite cold and must have been near winter time. We left the

home with Miss Tunley. I was so glad that I had my sister with me. Miss Tunley's car was in the drive, we got in and she drove off. I think it is so sad that no-one would have known we had been at Bledlow Home at all. Nobody said "goodbye", there was no feeling of warmth or any kind of bond. Miss Tunley was just the lady that had dealt with our case. She drove on and after quite a long time she stopped the car outside a building. We now know it was Beaconsfield. She was collecting our little sister Jean. We were to be together again with these people, Mr and Mrs Green. To this day, I still don't know where they lived — I don't think we were ever told.

Our sister Jean was in the car, she seemed so tiny, with dark hair and brown eyes just like Edie. I had fair hair and blue eyes, but that didn't matter, anyone could see we were sisters. I can't remember saying anything to her or even touching her. Jean looked unsure of us all anyway. Who could blame her? This uncertainty about things was to follow her through the rest of her life, but we didn't know that then, how could we?

After quite a long time travelling in the car, we arrived at a house. It wasn't a big house. It had red bricks and faced onto the small road that we had just travelled on. Miss Tunley stopped the car and took us towards the door which opened as we got there. A short plump lady, with short dark hair held back with a clip, stood there. We were taken inside by this person and Miss Tunley followed us. They were both talking and at the same time we were being ushered to sit down at a large square table. It was covered by a wine-coloured

tablecloth. I can remember the feel of it, soft but heavy. The woman looked stern. She didn't smile at any of us. She took the parcel of clothes that was being given to her, nodding her head as she did so.

A man came into the room and Miss Tunley said he was Mrs Green's husband. Miss Tunley then told my sisters and me that we were going to live with these people. She assured us that she would be keeping in touch with us and would call to see how we were getting on there. The name she used for them was "foster parents". The woman was still nodding her head as Miss Tunley left the house. I didn't like being there, and by the look on my sisters' faces they felt the same. The moment Miss Tunley had gone, the woman came back into the house. Her look was just the same as before. For the first time since we had arrived she spoke.

"Get down there," she said as she pointed at three stone steps which led from the small front room down into a scullery. We moved right away. She wasn't messing around and her tone was enough for us all. It was very small down there, a small table on the right and some chairs round it. On the same side was a white sink. A mirror hung on a dresser-type thing on the left, which made the place even smaller. It was more like a passageway than a room. Further on was a small place to do the cooking, then the back door. We were taken outside. The garden at the back was quite big. Chickens were in a mesh run, and beyond that a lovely place called a spinney with lots of little trees and bushes. We were allowed to play in there, said Mrs Green as she

went into the house. This was to be our wonderland. A world of our own for playing and digging with sticks, finding small pieces of china hiding under the soil and keeping them safe. It was going to be a different life for us all.

It felt strange, the quietness of the spinney. We had been used to the bustle of the home, all the other children. This was something so different from the life we had lived since we were tiny children. We also had to get to know Jean and she had to get to know us. After all, Jean had been away from us for a long time, so I think we were pretty unsure about each other, but there was also a feeling of protection towards this little girl we were playing with. It was the first time we had all been together for three years. It's strange but in a funny way our inner selves must have known this was how it should be. Out here it was so peaceful, a feeling of freedom, no high gates or fences. This must be how other children lived, like the ones who had lived in Bledlow village, the ones who went to school with the Home Kids.

It wasn't long before we knew just how different it would be. Mrs Green was a very sharp lady. Her voice and manner were very like the training girls at the home. We had been playing for a while when she called us into the house. Her voice was firm and she meant it. The three of us did just as she said, no second call was needed, we moved. Once inside she took us through the small sitting room and a door which led us upstairs. The bedroom on the right-hand side was for us. Again, this wasn't a very big room. It probably looked small

because we had been used to the dormitory. There was no warmth at all, just like the cold feeling I was getting from Mrs Green.

After being shown our room we went downstairs. Mrs Green made it quite clear where we would be living right from the start — pointing to the scullery and the table down there, we were told! We lived in there all the time, took our meals and had our wash time all in the same little place. Thinking back it never seemed big enough for one, let alone three of us. Both she and her husband spent all of their time in the sitting room. We never spent any time with them at all. We were three steps down but she didn't miss a thing that we did, she had a mirror placed on the wall. I hadn't seen it at first, but from where she sat she could see every move that was made by us. I can't remember reading a book or drawing. What did we do there? This again is a blank spot in my mind. How did we pass the time? Just what did we do in between playing outside and bed?

CHAPTER
SIX

We went to the local school, I am sure about that. I can remember when school time was over, all three of us used to make our way along the road, past the small shop. Other children, I can remember, called in to get sweets. We didn't because we didn't have any money, but it wasn't long before we found out that you didn't need any. We were told by the others that the way to get sweets was that the small children took the ones that were low down on the shelf, while the bigger ones spoke to the old lady serving people. I am rather ashamed to admit that we did do this, even though we knew it was bad. No-one ever caught us, and the sweets that were left over by the time we got back to Mrs Green's house we hid under a bush at the side of the garden. They were always soft and wet the next day but it didn't matter to us, we still ate them on the way to school.

Jean was such a tiny little thing. She found it very hard to walk such a long way to school each day and the weather was bad and very cold. As I was the biggest of the three, I used to carry her a lot of the way. Edie would get cross with me and say, "Make her walk, *we* have to!" I always felt the need to look after Jean. Edie

and I often fell out about this even when we were a lot older. The worry for Jean was always there and it's still the same to this day. You see, she had a lot of distress from such a small age that it never left her. Her life has always been in turmoil just as it started for all of us. The scars that were on us all affected us in different ways.

One day we were coming back from school, chasing each other playing tag. Edie was ahead of us two, I could see her running towards this bright green grass on the edge of the road. Suddenly she was flung forward, her body crashed downwards and she screamed. When Jean and I reached her, there was a lot of blood rushing from the top of her leg. We were both crying as we looked at it. Embedded in the leg was barbed wire, and we couldn't move her. It was an awful sight, there was no way we could help her. From nowhere some people came to our aid, an ambulance was called and Edie was taken to the hospital, shaken and upset. Jean and I walked to the house to let Mrs Green know about our sister and where she was. Instead of showing any kind of concern, she was so angry! We think she must have made her way to the hospital, because her husband stayed with Jean and me. She was away a long time and was still cross when she got back. We could hear her voice going on at Mr Green as we lay in our beds. We just kept as quiet as we could, hoping she would stop. We must have gone off to sleep quite quickly because it was soon time to get up ready for school the following morning. We didn't get told any news about Edie, how she was or when she

would be home with us both again. We dared not speak to Mrs Green about it at all. She seemed to get more cross each day. So little was said to us both, we just went to school as normal, played in our spinney for a while and then went to bed. I realise, now I am a grown woman, that she didn't really want us at all. Why did Miss Tunley put us there in the first place?

Life for us went on as it had done since the first day we had come to this house. Edie came home to us from hospital — her leg had been really bad. When the bandages came off we knew the scar would be with her forever. Mrs Green did not like any of us very much, but she seemed to pick on Edie the most. I don't know why, because Edie always did as she was told. One day she was having her hair brushed and Edie moved her head away from the brush. With not a thought about it, Mrs Green brought the brush down hard on the back of Edie's head. Edie screamed as her head made contact with the marble side of the sink. There was an awful split on the side of Edie's head and it bled for ages. Mrs Green told Edie that if asked about it she must say she had fallen. I can remember thinking, she is a wicked woman and she tells lies. I hated her after that and never forgave her for what she had done to my sister. So many times I wished she would die. What an awful thing for me to admit to, but I did have these thoughts and I cannot ignore that fact.

Edie used to sleepwalk most nights. We would wake up to find her moving around the small bedroom, grasping the air and saying strange things. The thing was, this had only started since we had been in this

house. I can't remember her doing it at Bledlow Home, though maybe she did and I just can't remember it. Jean and I soon realised that this really bothered Mr and Mrs Green. It distressed them quite a lot, and they didn't know how to cope with it. Jean and I were fine, to be honest, we had been through more awful things than sleepwalking. To us it was only our sister doing her nightly thing, she would never harm us and we knew it.

One night we talked to Edie about what she did when she was asleep. She was worried at first, but I told her she was OK and always ended up back in her bed. She thought it would be great fun to pretend to walk one night, and made her way down the stairs. The funny thing was she held her hands outstretched in front of her, a thing she never did normally. Jean and I were keeping our giggles down in case we were heard. Edie even knocked on the door at the bottom of the stairs! Mr Green pulled the door open, and shock and horror were on his face. We got back into our beds. Edie was brought back into the bedroom. We heard a lot of talk outside on the small landing and then our door was tied with a dressing gown belt to the wooden bar that was against the wall. Every night after that we were tied in once we were put into bed. It was then I knew that this woman we had to stay with had something she was afraid of, just as we had been afraid of things all our lives.

Our life carried on with the Greens; we three girls living in the scullery, she and her husband always in the top room. The mirror on the wall kept her in touch with our movements. We always had powdered egg

made into scrambled egg. Edie and Jean just couldn't eat it. They would sit there and Jean would get upset to the point of feeling sick, each mouthful made her heave. I had to wait until I felt that Mrs Green was busy talking and then push their powdered egg on to my plate. I can't remember how many times we did this. Mrs Green would then call us to take the crusts from the toast that they had had for their breakfast down to the chicken run. We never had toast, so we used to break the crusts in half, eat some and give the rest to the chickens. You see, she always checked that we had put the crusts into the run. We did get caught right at the beginning but we got a lot wiser about her ways. I know now that one does not have to be taught to be crafty — just watch others and you can learn.

Miss Tunley made her calls as she had said she would. Mrs Green must have been told in advance by letter I suppose. Anyway, we always knew when this was to happen because we were made to change our clothes. She used to brush our hair and then we were told to come on up into the sitting room.

"Don't you tell Miss Tunley that you live down there," she would say, pointing to the scullery steps. We must have looked fine, as if this was the normal life we led. Miss Tunley never stayed very long and Mrs Green always looked at ease when she left the house. No sooner had she gone than, "Get your clothes off, get dressed and get back down there," Mrs Green would bark at us. We did just that, it was freezing down there and Jean used to cry with the cold.

One day I couldn't take it any longer and must have plucked up the courage to do something about it for Jean's sake. I don't know how I dared but I asked Mrs Green, "Please let Jean come up into the room by the fire." She looked so mad, but I think she knew that Jean would be ill with the cold if something wasn't done for her. Grabbing Jean's arm she dragged her up the steps and slung her under the table. The wine-coloured cloth hung down with a fringe on the edge of it. Jean couldn't see a thing under there but at least she was warm. If she moved nearer to the light, Mrs Green would shove her back under with her foot. Edie and I stayed where we were and Jean was often kept under the table in the warm. Life was better for her at least.

CHAPTER
SEVEN

Mrs Green was a bad woman who enjoyed inflicting pain. All the time we lived there she seemed to hit Edie the most. We had, as you know, been put there by the local council, and I feel the main reason we three girls coped with the situation was the freedom the small spinney gave to us. Our spinney was our wonderland, and anyone seeing us there would not have thought we were the same girls that lived in the house. I can't remember having any neighbours at all, perhaps we didn't — this is a part of my mind that yet again will not let me remember, but this is something I have coped with. Inside the spinney, the trees were so high, the sun glinting, peeping down on the three of us playing, finding so many of our treasures, small bits of glass and china sparkling in the sunlight. Each bit was met with little shouts of pleasure — how did they get here and what was here before the spinney came?

Then, once again, we had to go back into that awful house, back to face whatever she dished out to us. Her husband never said very much at all but she didn't like us, that's for sure. I always hoped for a sunny day when I woke each morning, I knew then that I and my sisters would get a chance to go to our wonderland, and I

wished that the sun would never ever go down for us. I never knew then that years later I would be reading the most wonderful book, a book of true life, and discover that the lady in it did the same thing, finding glass and china in the woods (*A Breath of Coal Dust* by Edna Scott). The children of today would never find this a treasure, but something so simple could give so much pleasure when we were small. How sad that children miss so much by being given too much today.

My sisters and I knew the seasons, not because we were told them but by the sun. The times we were left to play in the spinney, the sun shone for us, freedom was ours, with small wild flowers to enjoy and buds on the trees and bushes. We got lost in our little worlds, each one of us doing our own thing but never far from each other. As I am sitting at this moment writing this, I can feel the wonder of our time in that spinney. I had never felt like this before and just by looking at the faces of my sisters I knew they felt the same as I did. I can't tell if we had such things as holidays from school, I suppose we did. It was at these times that we were left to play until quite late in the evening, there was no danger there. The spinney was right away from the house and in those days cars were never seen, only the one that Miss Tunley drove to see us in. There were more birds, more flowers and more trees then, I'm sure there were. Life for us was good outside, although the dark feeling always came back. When it was time to go indoors, even though the sun was still shining outside, it was dark and cold in the house.

36

One morning Mr Green spoke to us all. Mrs Green, he said, was going away on holiday, Guernsey I think he said. He never had a lot to do with us really. Ever since we had been there she always had the say about everything. He would be looking after us for the time that she was away. I can remember thinking it was going to be lovely not having her always there, always cross. Again, I found myself wishing that she wouldn't come back to bother us any more. In fact, later on that night I went to bed with this thought on my mind. I didn't feel bad about it all, Mr Green was a nice man. He never talked much, as I said, but he had never been cruel to us, ever. I found myself looking forward to Mrs Green going.

We were not told who she was going with or for how long. Never going on a holiday ourselves we did not know what it was all about. Anyway, she went and for the first time since we had lived there, we were allowed to sit in the sitting room at the table. This I liked very much. It was lighter than our place and Mr Green let us listen to his wireless. Again, I wished that Mrs Green would stay away from us all, but part of us knew that this couldn't last for always. How right we were.

One day we were out playing and Jean said she didn't like her glasses. She had to wear them because she had a squint in her left eye. When she could, she would take them off but up to now she had always been told to put them back on. Maybe she sensed that Mr Green would not think about them. They were little ones, I can see them now, wire frames hooked round her little ears. We had been digging in the soil and it wasn't until we were

back in the house that Edie asked her, "Where are your glasses?" Jean said she didn't like them, so she had buried them and then jumped up and down on them until they were broken! It wasn't funny really because she never had glasses again. No-one seemed to even notice she was without them, that's how important we must have been. People didn't have to answer to anyone for their actions as nobody outside would be looking for us. How we were being cared for wasn't of the greatest importance, but then we were in the same boat as many other children, I'm sure of that. It had been a lot worse for us in the past.

We got up one particular morning, and Mr Green looked upset. As we came downstairs to get ourselves washed, he told us Miss Tunley was coming to see us, and that was it. He then started to get our things together. All we had were clothes — toys as they are known now did not exist. It was like we were going away, I thought, we all did!

Miss Tunley arrived and we were told that Mrs Green had died, the cause of her death was food poisoning on the boat coming home. I remembered the thoughts that I had had when she first left the house for the holiday — not only thought them but said them to my sisters. I've got to be truthful, I was glad. It must seem that I am a very wicked person to have such thoughts but the truth must be told.

I do not have any idea just how long we lived with the Greens. The weather had been cold when we first arrived at the house. We had been through a spring and summer as well, so trying to work it out I feel we had

spent about eighteen months or more with them. Christmas had come into that time, because I can remember we spent the day in the bedroom with a box of wine gums, each playing shops, pretending some of them were pennies.

Anyway, Miss Tunley got us all into the car and then told us we were on our way back to Bledlow Home. It's strange but I was glad that we were going back there. I don't know why I felt this way, perhaps I thought that's where we should have stayed in the first place. We arrived at the home, again this is a blank part of my mind, going inside the gates. I don't remember getting sorted out in the dormitory, or even meal times, it's all just a blank.

CHAPTER
EIGHT

I can remember Edie talking to me at every moment she could, telling me stories about our old life at 460 London Road, High Wycombe. Maybe because I was now older, she felt I would understand things more. The thing that stuck in my mind more than anything was that Edie said we had *brothers* and sisters. The home people had told us that we were alone, just us three. Edie insisted that she was right and could remember older girls, four of them, and two brothers, one brother she said was called Patrick. Mother, she said, was in a wheelchair. I began to feel that, being eighteen months older than me she had seen all these things around her, sharing a bed with older sisters, she said. All at once things in my mind started to make more sense to me — the way Edie described the railings at the front of the house, the water at the bottom of the garden. If she was making up stories then why could I see parts of what she was talking about? Edie was opening up a whole new part of our lives!

The sharing of the big bed I seem to remember, not that I can see who was in the bed with me, being so young I don't think it would be possible for me to know anyway. Edie told me that it was Patrick, a brother of

ours, who carried Jean up the hill to the hospital the day she cut her finger very badly. It must have been very deep because of the scar that she still has. All these stories put so much of our past life before me — it wouldn't mean very much to others being told it, and it didn't occur to them that we needed to be told. It's like objects in the mind instead of objects one can touch for real. I never got tired of listening to the stories, it was like turning the pages of a book, so much to learn and I had a good teacher.

Someone, somewhere, knew that we were there. I carried this with me all the time I was growing up. Always in my thoughts was that one day I would find out why we were put into Bledlow in the first place and why no-one came to take us to our real home. If Edie or I ever asked about these things that we kept remembering, we were always told, "You have no-one else or a family, only you three." Edie knew better and I was beginning to be just like her. We felt that a lot was being kept from us and we wanted to know why. As I got older that feeling got so much stronger that at times it was my main thought. I felt it was our right to know about our roots but nobody was prepared to tell us. Why?

Life at the home was as usual. We hadn't heard from Miss Tunley for some time, then one day she arrived. Jean and I were the ones she wanted to see. I was worried, why not Edie? I didn't like this one bit! Asked about this, Miss Tunley said Edie couldn't come with us right away but would follow. We were going to get some new clothes and once again we were taken to the

hut. All new clothes were put on us, and others that we would need got ready for us to take with us. Miss Tunley told us that we were going to live with some other people. We were getting used to this, we must have been, because I didn't have any worries, only the fact that Edie wasn't with me.

Once again, we were in the car with Miss Tunley and driving off. On the journey she told us that we were going to live with Mr and Mrs Horwood at a little cottage called Beersheba, near Tingewick in Buckinghamshire, and that they were very kind people and we would like it there. I had my doubts about this, from living with the Greens many thoughts were passing through my mind. We went past the Chiltern Hills, I know that now. Back then they were what we called the chalk hills. Onwards we went to see this cottage that we were going to live in with these new people. I would have felt better if Edie had been with us.

The sun was shining as we went along in the car. It was such a nice day and Jean looked as though she was happy. Miss Tunley told us that the people who were having us had come to Bledlow and chosen us to live with them. I don't remember anybody coming to see us or talk to us while we lived there, but it must be right, I suppose — we were going to them, so somebody had decided that was what was going to happen to us.

All in all I felt quite at ease — a feeling I hadn't had before. Perhaps it was because I was seven now and understood that this was how it had to be. We had never really belonged anywhere and I never realised until I was much older how kind Miss Tunley had been

to us, by keeping us together. All our life she had been the only mother figure we were likely to have. Life is strange; everything she ever did for us was done for us alone, and it took for me to be a mother myself to realise this. We have a lot to thank this lady for.

As we pulled up at the cottage I thought how lovely it was, grey stone. It was on its own, a small stream ran at the back of it and lots of open land, green fields. The only other place nearby was a large house right up on a hill but a long way off from this pretty little cottage. Was this really the place we were going to be living? There were chickens, and logs of wood were piled by the side of the wooden shed. Two dogs were jumping about, I could see them at the side of the cottage. I felt nerves, but happy inside about this place.

The cottage door opened and a very pretty lady stood there. She had dark hair, was slim and wore a pretty floral dress. Her face was kind and she was smiling at us all. She asked us into a small front room. It was so nice in there, either side of the black range were small fitted seats and we were asked to sit down. Jean and I did so. Miss Tunley said that this was Mrs Horwood and she would be looking after us. She was so nice, I felt it at the start. Mr Horwood was still working, she said, but would be in soon. They talked on but I can't remember what about. Everything in the room was so bright and clean, just like the lady who lived there.

It wasn't long before Mr Horwood came in. He was a broad man, tall and very handsome. He smiled and said "hello" to us all. These were very nice people, I

knew right away. Miss Tunley stayed for quite a long time, then we were on our own with our new foster parents. We didn't say very much, it was strange. Such nice people but I know now it was just as strange for them. They had never had children of their own, so now I realise they had taken on a lot, two of us. For them it was their beginning of a family. These two wonderful people were the ones who would share their wisdom, give us love and earn our respect.

"Let us have some tea," Mrs Horwood said, and asked us if we took sugar. I couldn't believe that we were sitting at the same table as they were, and I felt so good just being there with them.

After we had had tea, Mrs Horwood said we must look around the cottage with her. We followed her upstairs. There were two bedrooms; one was theirs and the other was for us two. I felt very good when I saw three beds, as I knew then that Edie would have a bed waiting for her when she arrived at the cottage to join us all. Again, everything was so neat. The window looked out onto the road and we were able to see the green fields stretching right up the hills.

Jean was asked if she would like the bed next to the window. This she thought was great. I was in the middle, so that left the one next to me for Edie. I felt so good inside about everything. We had a dressing table and a small wardrobe as well in our room, not that the room was big but we were able to walk past the end of the beds quite easily. Even as I stood there in the room, I knew things would be so different from what we had known in the past. We went downstairs and were shown

44

the kitchen, and there was a walk-in larder. I was so surprised to see bottles of preserved fruit, shelves of them. Eggs were put down in a chalky white mixture in a big white bucket. This walk-in larder was full of goodies. This was something that we had never seen before, but Mrs Horwood didn't mind us asking any questions and gave us a smile when answering. She said that we must come and see the garden and the chickens, and bantams that they kept in a run. Outside was really nice, all open, a lawn then piles of logs. They were to be cut up for the fire, she said. When the time was right Mr Horwood would do that job! We were full of wonder at this place, and thought it was great to be told that we would collect the eggs daily but we would have to hunt for them as the chickens laid them all over the place. This seemed fun. No-one had ever been this kind to us. We followed this lady around like we had known her forever. There was a calmness about the whole thing, a feeling I had never really known before.

We went back into the house and Mr Horwood asked us if we liked what we had seen. He told us all about his work. The farm, he said, was just up the road and he also did welding for people. We would be able to collect the fresh milk from the farm each day for Mrs Horwood in proper milk holders and then walk back home with it. This may not seem very much to a child brought up in a family, but to me it was wonderful. I was so glad that we were here and it was fine for us to wander in the cottage so freely. We all talked until bedtime. That awkward feeling we began with was

going and I felt we were all more at ease with one another.

All our toilet things were got out of our bags and we crowded round the kitchen sink to wash. We even had supper at the table in the sitting room, and hot cocoa. It was time for bed now. We said our goodnights and Mrs Horwood took us up to our room. We were tucked in — a thing we had never known in our life before. "See you in the morning," she said, "God bless." I lay there just thinking this lovely lady was downstairs and she was *ours*.

I woke up and for the first time in my life couldn't wait to go downstairs. Mrs Horwood was already up. Breakfast was laid and tea, toast and cornflakes were ready for us both. Mr Horwood had gone to work but we all sat down together to eat. It was so nice. Mrs Horwood chatted about the things we would do for her and each other that day. She mentioned about the milk we would collect for her and said that when we went to the farm we would see Mr Horwood at work.

Breakfast finished, we helped to clear and wash the dishes. We then went out to check the garden and the little stream that ran at the back of their land. We saw tiny rabbits along by the hedgerow and the dogs seemed to like us being there. When it was time to go to the farm we couldn't wait. Mrs Horwood took us towards Water Stratford village. The farm was really just up the road. We passed over a small bridge, it was so pretty, all around us were fields and everywhere was so green and fresh. Mrs Horwood pointed to the left side

of us as we walked, and said, "This is all our land." A large part of it was full of vegetables, every kind you could think of, and on the other land were pigs that Mr Horwood kept. Mrs Horwood said. "They go to the market so we must not get fond of them or we may get upset when they leave us." I couldn't believe it — she was concerned about our feelings! Nobody had ever bothered about such things before. Of course I felt Miss Tunley had kindness for us, but she was the only one who had. Looking at Mrs Horwood, she seemed quite young. I didn't know until a lot later she was only in her thirties, her husband about two years older than her. But I could see even then that she had a strong feeling for us right from the start and later on in life we would know just how strong that was.

When we got to the farm Mrs Horwood told us to go for the milk, taking our lidded jugs — she felt sure we could follow the road back together. She was going to let us do that. I felt very grown-up as we said "see you later", then we walked into the farm wide-eyed and looking for Mr Horwood. We found him dealing with a tractor in the yard. You could never have guessed from the way he greeted us, that we had just come those few hours ago to live in his home. He smiled and called us to where he was standing, stopping what he was doing. We were taken all around the farm and ended up at the milking shed. We had never seen anything like this in our life before. We stood there and the fresh milk was ladled into our jugs with a special measure. It was the first time we were allowed to take charge of a job on our own. Mr Horwood said he would be home for

lunch time and told us to take care on the way back. It took us a lot longer, I can remember, to go back than it had to get there. We took in everything as we strolled along to the cottage. I don't think even our spinney could beat the feeling I had that first day. The sunny day, the freedom and two people who cared, what a lovely day this was going to be. We rounded the corner and there was our house. We walked into the garden and handed over our milk with great pride.

It wasn't long before we got used to our life with them both, though our lives had changed so much in the short time we had been there. I still knew inside that we were Home Kids but there were times when that thought used to fade and I felt more sure of things. Mrs Horwood was always there, and if we fell over sometimes, or felt upset, she would always put things right for us.

One thing was missing from my life and that was my sister Edie. Mrs Horwood would say, "She will be coming here soon," but it seemed ages before she did arrive. Years later I was told that Edie had been prone to having fits since she was a small child, but I had never seen this happen — then it came flooding back to me. The pretty little girl, so long ago at 460 London Road, standing under the stairway, shaking and being held by the arms by someone — that was Edie. Another blank space in my brain had been filled.

The day Edie came to the cottage I can't describe my feelings. Mrs Horwood soon made her feel wanted, and she had the proof she needed by looking at Jean and myself. We soon settled down as a new family, helping

48

Mr and Mrs Horwood on their land with all the work and the pigs and chickens. We had to do it anyway, that was made clear to us all. We did so many rows of hoeing before we could go and play but we didn't mind — that was his rule and it did us no harm.

Inside the cottage Mrs Horwood taught us to keep a house and to cook, and we each had jobs to do. She was a great cook and we learned how each vegetable should be peeled and presented at the table. Apple pies were made, we were sent blackberry picking, and jam was made with all kinds of fruit. There were so many different things we didn't know about, things that others would have taken for granted — newspapers, eggs, tractors, pretty white underwear, Christmas trees and candles. I can't list them all, but all these things had been in the outside world that we had never known about until now. It must be hard for anyone to know or understand unless it has happened to themselves.

Bath nights were lovely in Beersheba cottage, so different from the home up at Bledlow, feeling frightened and waiting for your name to be called. No, it was nice when the big metal bath tub was brought into the kitchen by Mr Horwood, and Mrs Horwood got it ready for us — the water was already boiling away in the corner copper or in the two big kettles that stood on the gas rings. A big white enamel jug was always kept on the draining board — I can see it now, a chip on the side of it showing that it was put to good use, there it stood waiting to do its job. I realise now just how proud

Mrs Horwood was of us all. The jug was an important part of bath time as we took our turn, our hair washed with soap (we didn't know about shampoo) but the final magic was to come. Mrs Horwood would nip outside and fill the big jug with rain water from the butt. "That final rinse did the trick," she would say. Our hair shone like silk. Try as I might, I can't get that same shine today. Each of us in turn would be rubbed dry with a big towel. She would fluff up our hair to dry it, each one had the same warm comfort at bath time. We would sit by the black range and drink hot cocoa, it was lovely. Mr Horwood was always there at the end of bath time to take the big bath outside to empty it for Mrs Horwood.

As a child I didn't even give it a thought that times like this would ever leave us. These were treasures in our life and we took all these wonderful things and feelings without a thought at the time. Now, in middle age, I know that so many children will never feel the warmth that we did. Bath time to lots of children is a bore. I know that certain values in life have changed, but why must they take over the best things in life? I made sure that my children had a bath time as near to my own as possible, cuddles and warm towels and a nice warm drink to end with. I really wish our haven at Beersheba was still there, the bridge, the pebbles below, shallow water running over them. We still visit the spot, and the same good feeling comes over me as I stand on the little bridge. My children and their own children love the place. The disused railway line still has violets

and cowslips up the banks. We look but don't pick as we did when we were kids. Yes, a great part of me is still in Buckinghamshire where the cottage was and the stream still flows.

CHAPTER
NINE

Mrs Horwood took us to the village, which was about two miles from where we lived. Tingewick it was called. She showed us the school and small shops where she did the shopping, The school looked nice and she said we would be going there soon. I think it must have been summer school holidays, because it was some weeks before we started at the school. I really wasn't looking forward to going — I was unsure about the children we would meet there and I couldn't help thinking what we were called at Bledlow. I wondered, would it all be the same again and must we really go there?

All three of us started at the same school together, a change from the two by two that we had left behind us. We had to walk to school but it was a lovely walk and I can remember little Jean needing a piggy back part of the way. There was only one house we passed on the way, and as we walked everywhere was green with pretty wild flowers, open fields. There was so much space, we were lucky to live there. When we arrived at the school we felt fine about things. The other children were full of questions but no-one called us any names. I can remember we stayed close together even as we

entered the school as the bell rang. Inside, the teacher took charge and Edie was put at one end of the classroom and I was put in the front. Inside the desk were books, pencils and scissors, and I had my own inkwell, as the pen had a nib on it. I had never used one like this before. Mid-morning came and small bottles of milk were given around the class. I can remember leaving the creamy part of the milk until last by pushing the straw to the bottom of the bottle. I liked it here and I know my sisters felt the same. The promise I had made myself so long ago was coming true, it wasn't long before I had lots of new friends and they really liked me just for myself and no other reason.

The walk home to the cottage that day was full of happy chatter. Each of us was so full of our day, life had a meaning, we belonged here and it got better and better for all three of us. Up to this point in our lives Edie and I had always needed to feel the presence of each other. Now we began to have our own friends to visit us and to make return visits to their homes.

On Mr Horwood's land a small river ran along and willow trees hung over it. We were able to bring our friends here and Mrs Horwood would pack a picnic for us all. We would leave the cottage to get to this pretty spot and spend our time down by the river. Mr Horwood had said we must learn to swim. The only place in those times was the river. He took a long time putting up a wooden platform and a swing. We all used to take turns to lie on the swing and be shown the movements of swimming. Everything he told us to do we did. Both he and Mrs Horwood were very good

swimmers and he felt very strongly that we must be the same — that way we would be safe to go to the river at any time, and they would feel more sure about letting us go. It wasn't long before both Edie and I could swim, and he helped us to achieve that. Jean was never very keen to learn and she was never a swimmer. Clay Bottom was a lovely place to go to, again willows hung over the river and our friends enjoyed the beauty of the place as much as we did. I shall never forget those days, or the two people who made it all possible and changed our lives so much.

Christmas was something very special with Mr and Mrs Horwood. He sent Jean to bed early by putting the hands of the clock forward. It gave him more time to build her surprise for her Christmas present. Jean would say, "It can't be time yet", looking at the clock. Mr Horwood was making her a big dolls' house. He stuck a peg in the door handle in case Jean came downstairs and saw it. It was a copy of the cottage that we lived in, and it was wonderful. The windows were carved with a penknife, it had a fireplace and little curtains at the windows. It took him many weeks to make it and I could see that he enjoyed making every bit of it. Jean had kept asking for a doll but was told they could not afford it.

On Christmas Eve the tree was put up in the front room — we didn't use that room every day so that was an exciting thing. The clip-on candles were put on to the finished tree and we were so excited by now we must have been quite a handful to deal with. Christmas morning came and the three of us couldn't wait to grab

the stockings on the end of our beds. They were full to the top with small things, fruit and nuts. Jean dragged her stocking behind her onto the landing and then gave a squeal of delight, for there on the landing was a life-sized doll. She was made of soft sacking and her face was smiling. Mr Horwood had even dressed the doll in Jean's clothes, a jumper and a skirt which was red tartan. Jean hugged that doll all day, I remember, and it went everywhere with her. By this time, Edie and I had followed Jean downstairs and Mrs Horwood brought out some parcels, two for each of us. We each had a hairbrush set with a mirror to match, Edie's was green, mine was pink and Jean had a blue one. We also had an apron each. We then waited for Jean's big surprise — she couldn't believe her eyes. I think that the dolls' house was the most lovely thing she had ever seen. Mr and Mrs Horwood's eyes filled with tears, they were so happy. The candles were lit on the tree just to show us what they were like. Everyone was happy and we had a wonderful Christmas. I didn't know Christmas Day could be like this. Mr and Mrs Horwood didn't have a lot of income, but they made sure that we never knew about this for many years to come.

I can remember one time that Mrs Horwood did get very cross with a lady in the village. This person had stopped us once and started to ask us questions about where we had come from, and about the family we had had before living with Mr and Mrs Horwood. Well, we couldn't say very much to her anyway, we didn't know much, only that there was just us three. I can remember

her saying, why did we come from a home? Again, we could only tell her the truth, that our mother had died and left us. We told Mrs Horwood about this nice lady in the village and she got very mad, not with us but at what she had just been told. She got onto her bike and off she went, we didn't know where to at the time. Later on that afternoon she was telling Mr Horwood, and I quote: "I told her that if she wants to know anything about my girls, don't question them again, you ask me!" Then the woman added that she didn't know Mrs Horwood had three girls and where did they come from? Mrs Horwood retorted, "Oh, I kept them in the wardrobe and have just let them see daylight." I remember we giggled but she was very hurt by it all. I knew for sure she would never let anyone hurt us if she was there.

I really wish I had a photo of the terraced house in High Wycombe where we lived at the beginning of our lives — after all, that's where it all started. The one photo of my blood mother that I was shown is probably in a box somewhere, meaning very little to anyone else, but I have her picture in my mind that is very clear to me. After all this time it's sad that I can't share that with anyone. It's almost as though my life started in the home at Bledlow Ridge. Why can't I remember before that? Is it because I can't, or that some part of my mind just won't let me? All these years of wondering about the past and what I felt we had missed, but it wasn't like that at all. It was as if life for us was paved. We took it step by step and, I didn't realise it until now, we were the lucky ones. All the hurt we felt and all the lost

feelings, and thoughts that no-one cared, this was leading us to a much better life. None of us knows what's in store for us, so in that respect we are all equal. Much later on in life we learned that the others in the family had very little to be happy about, and they were the ones who were kept in the family home. Life is strange, for sure.

CHAPTER
TEN

One time that is so clear in my mind was when a fair had arrived on the green at Tingewick. The children at the village school had told us about it and we asked if we could go. Mrs Horwood said we could. The three of us left the cottage very excited. It was the first fair that we had ever been to. There were lots of lights and rides to go on. Edie and I went on together but it wasn't long before I had to get off. My head felt so bad I decided that I was going back home. I think Edie and Jean could see that I really wasn't right and came home with me. All the way back I felt weaker and weaker in my legs, and was so glad to reach home. Mrs Horwood was so surprised to see us all back so soon, but by this time my vision was strange, and all I wanted to do was lie down. We all thought it was the rides at the fair that had caused this feeling. Mrs Horwood took me into the sitting room and I can remember lying on the settee while Mrs Horwood dealt with the baker who had just called.

I was changed and put into bed. I felt so weak and just wanted to lie still. I think Mrs Horwood knew then that it wasn't something mild. The next thing I knew, Edie and Jean were put into the other bedroom and Mr

and Mrs Horwood were sitting beside me. The room was spinning round, it would not stop. I heard Mrs Horwood say, "We need to get a doctor to her." The room was so dark, the only reason I knew it was late at night. I seemed to have missed most of that afternoon. They seemed worried at having to fetch the doctor out. I felt a needle go in my bottom and a voice said, "It's a good job you did, she may not have been here in the morning." I had pneumonia. I had had it as a small child, it seemed, and Mrs Horwood must have been told this or our case history would have shown it.

Doctor Young came to see me and I had more injections, but I still couldn't eat and kept messing the bed. It must have been awful for Mrs Horwood, she just kept changing the sheets and washing me down in the bed. Time after time this went on. They told me that I had been very ill and delirious. When I did seem to be brighter, I was given one teaspoonful of rice pudding, that's all I could take. Not once in all this time did Mrs Horwood leave me. Mr Horwood took over in the evenings, sitting there making springs for the day's work ahead of him. I got stronger as each day passed but it left me with a shadow on my right lung and I still get out of breath very quickly. When all the other children ran everywhere I had to stop and walk. I feel I was very lucky that Mrs Horwood got the doctor at midnight when I was so ill.

One day we were having breakfast as usual and Mr and Mrs Horwood said they wanted to have a talk with the three of us. I felt worried, both of them looked a bit concerned and dreadful thoughts were going through

my mind. I thought we were going to be sent back to the home for some reason, I couldn't think why though. I need not have worried, our world was not about to crumble but something quite the opposite. They said there was something that they wished to ask us. How did we feel about calling them "Mum" and "Dad" — they would like it but how did we feel about it? I had mixed feelings about it, those were two words we had never used before. We said we would like it, but I felt sure Edie and Jean felt strange about it, just as I did. What would come easily to other children, didn't to us. Anyway, we tried it but kept slipping back to "Mr and Mrs Horwood". Then one day it must have fallen into place and the words "Mum and Dad" came so easily. This may seem strange to other people, but to start with these two words were the hardest to say and to have a true meaning. We were like others now, we had a Mum and Dad who really loved us, and we loved them.

As we got older the cottage wasn't big enough for us all. A decision was made and Mum and Dad told us they were moving house to Tingewick village. My first thought was how sad they would be, never to roam and have the freedom that we had known for such a long time, the fields, the river, the farm land. In my heart I knew that this was something that I would miss forever, even writing about it now gives a feeling of loss. Mum said the cottage would be pulled down soon anyway but even that didn't change the way I felt about it all.

Tingewick village was pretty enough, but nothing could compare with what we had come to love. I know

that no-one in the family ever really knew my true feelings on having to leave the cottage and telling them wouldn't have changed a thing. We were older now — the age of eleven came so quickly for me. Edie had already moved to Buckingham Secondary Modern School, and I was to follow. We had to go by bus as it was quite a long way to this new school from Tingewick. But even going to this new school didn't worry me because any doubts were soon eased away by talking to Mrs Horwood. The bond was getting stronger between us all and I knew this — so did my sisters, although not one of us had ever said it aloud, we just knew. Jean was still at the small school in Tingewick, Edie and I were at Buckingham, and the next thing we had to cope with was the older girls asking why our surname was not Horwood. Thinking back on it now I'm older, I really don't know why it was such a big thing but it was at that time. A feeling of guilt at being fostered came over me and I did all I could to avoid talking about it. I can't explain those feelings, I always felt a stigma attached to not having our own mother and father to bring us up. This feeling got worse later as I started to go out to work and when I was allowed to have boyfriends at the age of sixteen. Oh, if only I could have realised that it didn't matter or make me less of a person! At that time I never told anyone how I felt — it would have hurt Mum and Dad, I feel sure, if I had.

Mum and Dad had a reason for not adopting us — money was tight and I learned from Mum that the small amount that came from the County Council

helped out with clothing us. I have always admired them both so much for taking on three girls. I also learned later that they had planned to have two boys but ended up taking on three sisters. That's the wonderful sort of people they were. Never in my life could I repay Mum and Dad for the gift of love they gave to me and my sisters.

CHAPTER
ELEVEN

When we moved to Tingewick life was so different. We had been used to the green fields, the river so calm, just us in the small cottage. It made me feel quite sad leaving all that freedom. Well, that's how I looked upon it but I never told anyone how I felt, not ever. I missed the chance to go to the farm. Dad played a big part at the farm, it was as though it was ours and we were always free to do as we liked. It really had become part of our lives. We had neighbours now, and the house didn't have that same warm feeling in it, not like our cottage did! Maybe Mum felt the same. Dad didn't mind, he did the garden how he wanted it and spent most of his time doing up motorbikes.

Thinking back, he and Mum never went out together, not that I can remember anyway. They never mixed with other people and kept very much to themselves. Mum's greatest pleasure was doing things for us three girls. When Edie and I were confirmed she made sure that our dresses were both the same, white with a small red design on them, black patent shoes and both had a veil. One should make sure that every day is lived and enjoyed to the full, and these times should have been! If only we had realised at the time, but a

child's mind doesn't work like that. We had friends, they lived quite near to us but we were not allowed to bring people into our house. Mum didn't like it. This was the pattern of our lives, I guess, until we left home.

It was time for Edie to leave school. She had reached the age of fifteen and it was time to start work. She got a job at a laundry at Gawcott near Tingewick, and before long I reached the same age. Edie was well settled in her job and I joined the same firm. At that time there was very little work, only a few firms around. Some of the girls were quite nice, others I stayed away from. They had quite different ideas and values than we had been brought up with, and Mum would have been very upset had we taken the road that some girls had. She had always made it quite clear, as we grew up, about life and what she expected from us all. It would have been quite easy to follow the same path as those girls, except for the fact that Mum and Dad had our respect and not one of us ever let them down. Even at work the bond between Edie and I was always there. Although we worked in different departments we made sure the other was always OK.

Life carried on this way until Edie left home. Mum and Dad worked at the MoD in Bicester and Jean was still a rebellious tomboy. I always found this hard to understand, as she was so meek as a tiny child.

Edie met a young man from Buckingham called Peter. She liked him a lot but Mum didn't like the idea of this. He had bad asthma and Mum thought Edie could do without this worry. Edie felt it was up to her. Peter played lots of sports and she could see no reason

for Mum's feelings about him. This was to be the first time that Mum and Edie had strong words. Peter wanted Edie to get engaged to him, but Mum forbade her to go ahead with this idea and said if she went against her wishes then Edie would not be allowed to see him ever again. This was like a red rag to a bull. A few days later Edie came home from work and said she was going to move and live with Peter's family. He came from a very stable home and I liked him a lot. I knew he had very strong feelings for my sister. Mum was cross about this but I also knew that she was very unhappy about losing Edie from our home. This was the most dreadful time of my life. The thought of Edie going away to live made me sick, I mean really sick! The feeling I had then I cannot describe to anyone. I remember crying like a baby as she packed things into her case. I felt sick to my stomach. Part of me left with her that day. We had depended on each other since we were little children and I could not imagine our house without her there. Although Mum and Dad had never said outright "I love you" to any of us, we knew that they did. Jean and I could feel the hurt Mum was feeling but no matter what we said or did, it didn't change her feelings about this young man, Peter. Many years later Dad told me that Mum didn't want any of us to leave home. He said she was so proud of her girls and never wanted to lose them to anyone, but I know life isn't like that and never could be.

When I brought my first boyfriend home she was fine with him, but then I was still at home with her and he was only a friend. I think now that Mum felt

threatened as we grew to womanhood but I loved Mum more than I can say in words. Edie and Jean grew to look more and more like her as they got older, so pretty all of them, dark hair and dark eyes. I was blonde and blue-eyed. I used to kid myself I looked like Dad. No family could have been closer than we were. We had been shown right from wrong, always went to Sunday School, and then to church to be confirmed, and were taught never to let others down or let ourselves down. There are three things you can give away to make people happy: Love, Hug and a Smile.

Life at home without Edie living there seemed to change. I've already said how lost I felt, for at times she was my best friend as well as my sister. We always talked things over together, if we had any worry about things. We went almost everywhere together and although the place she now lived was only a bus ride away, she and I didn't see much of each other. I was so glad that we worked at the same place and could talk there. She said she was all right at her boyfriend's place but she didn't seem to me quite right. Anyway, I felt that something was on her mind and I told her so. She said not to worry which made me sure that she was worried. It came out in the end that she had met someone else and she had very strong feelings for him. He was in the Army near Buckingham and was due to complete his service — he was moving back to Suffolk and had asked her to marry him. I had never seen anyone so in love with someone as she was with Bobby. The thing was how to tell Peter and not hurt him. He was such a nice person, she had to speak with him, she

knew, and was dreading it. In the end she just told him the full feelings she had for Bob. He was pretty upset about it all and didn't want to accept the fact that he had lost Edie.

Mum was asked if Bobby and his mum and dad could come for a meal at our home. Edie was unsure of the reaction she would get from Mum, but it was OK. I've always felt that Mum made a special effort for that first lunch. It was a Saturday. They behaved very differently from our family — they were very outspoken to the point of being rude. Mum, I could see, was not impressed but she made the meeting go well. If Edie was going away again she was making sure it was going to be on good terms this time, and I felt proud of Mum. We all knew that we wouldn't see Edie as often as we would like to because of the distance and we didn't have the money or a car to travel to Suffolk.

There had always been this strong bond between Edie and Mum, and as Edie had grown up she looked more and more like her. No-one would have known that she had been fostered in the first place. I was always helping Dad, any jobs that he was doing he would take me to help him. Jean was always the tomboy, tagging along, looking for mischief on the farm. When Edie moved to Suffolk there was no short-age of work, and this was what she wanted to do. My workplace was never the same after she left, but I knew that at the age of sixteen I could take a job in Bicester in the issues office at the MoD, so that was what I did.

Edie wrote to say she was getting married to Bob. Not a white wedding, but a registry office, as cash was

tight and Mum and Dad couldn't help. Anyway, we were always told that if you can't pay for it you just don't have it. Most couples today start off with almost everything, but Edie had a rented farm cottage. She was very happy and for the first time other than with us, her family, she felt secure. She was never shy of hard work and she and Bob did work for the same farmer. It was very peaceful for her. I'm sure they had ups and downs but she never said a bad word about him. He was her life and she told me once that she couldn't go on if he was not with her.

I missed her so much but just kept telling myself that this was how it was going to be and even if I wanted it different, it was too bad. The days of doing things together had gone, she had a husband now and it was up to me to make my own way without having my sister with me all the time. It was not easy but I had no other choice than to accept it.

CHAPTER
TWELVE

One day when I came in from work, Mum wasn't too happy about something, and I knew whatever it was she needed to talk to me about it. She said that there was a lump in her left breast and she had had it for a long time but had kept it to herself. She had been on the brink of going to the doctor's on many occasions but at the last moment had changed her mind. We talked, and I felt my own breast, saying I had the same lumps in mine, we all had. She shook her head and with her kind face said, "No, my love, we haven't."

Although we girls had only just been told, Dad knew about it and had said she must see a doctor. Mum had got as far as the doctor's, it seems, but decided against it. It only got worse and in the end Mum had to go to see Dr Young in Buckingham. From there tests were arranged for her. It was a bad day for us all when the doctor said Mum had to go to a London hospital, Mount Vernon. We were so upset for Mum and what made it worse, we could see she was upset, that was the awful thing. We could not make things go away for her, she had done so much for us and we felt useless to help her.

I used to say my prayers each night and now Mum was always first and last in them. The gap that Mum left while in the hospital was filled with the other special thing in my life, my faith. Mum was away for a long time and underwent three major operations for cancer. She was a very brave lady, I can now say I never heard her complain, ever. After Mum came home she used to get tired very easily and we did all we could to help things go right in the home — after all, we had the best teacher anyone could have had to start us off in life.

Mum was a very private person in many ways, she never had people in and out of the house so the worry she had was kept very much in our family. We would talk often and she told me so many things about her life, things that she had never spoken of to anyone until now. She felt that the cancer could have been brought about by the beatings that she had suffered at the hands of her stepmother. Her father did all he could to stop this but it carried on for years; a broom handle was used on her to poke at her body because Mum used to hide under the bed in fear of this woman. I always think that's why Mum gave us the wonderful life that she did, because she had known fear in a big way for many years and made up to us three for all that she had lacked in her life. That's what made her the person she was.

Dad decided to move house to live in Bicester. Both he and Mum worked for the MoD there and I was about to start a job in the issues office at the same place. Things went along as well as we could expect. Mum was going for treatment on a regular basis, but

the pain that she was in began to show in her face — the treatment was not doing what we had all wished it to do. It was hard for Mum to talk about things at the best of times and it was a case of showing her our love more than putting it into words. I am sure Mum understood this but as I said, she was a very private person.

I was unable to do more than I was already doing, working and then making it home to cook our dinner in the evening. Also on my mind were plans of getting married, and what it would be like when that moment of leaving home came. At times I didn't want to think about it, it was easier that way. Mum was still working at this time and Dad never seemed to show his true feelings. I never talked about the wedding to them very much, I felt that they didn't want it. Anyway, Mum and Dad had enough to think of at that time.

I had met Mick when he was working in the next office to mine and we seemed to hit it off right away. It's strange really, he was so kind, gentle and thoughtful. Me, I was more outgoing and made it clear from the start to everyone that I liked things straight but fair. I would say we were as different as chalk and cheese but we liked each other right away. The time came when Mick was moving back to Sevenoaks in Kent. He was going on to London College from there and he wanted me to move and live at his mother's home in Kent. I was not too happy about this plan. His mother had made her feelings quite clear about our engagement and I felt sure that things would be far from easy for everyone. Mum's health was on my mind,

Mick was in my thoughts. I had to make a decision and it was very hard to do. Things at home became more difficult. I could see the change in Mum, and how everything and everybody seemed just too much some days for her to be bothered with. She was not happy at the thought of me going, she never said but she didn't need to.

We moved to Bicester. I saw the house and it was so cold. I don't think Mum liked it either. Thinking back, it was Dad who made the decision to be there and to me it was never cosy, just a place to come back to after work. The cottage was always on my mind. Jean continued to be difficult, I couldn't understand her at times. Mum wasn't at all well and Jean's behaviour didn't help lessen the worry Mum was going through with her illness. It got to the point where Mum had to go back to Mount Vernon Hospital for yet another major operation. Dad knew more about this than he was prepared to tell us. Mum had been continuing to work but I could tell that she was very ill, and the hospital felt she needed more treatment. The thought of going back into hospital made Mum very depressed indeed.

I had moved to Kent by the time Mum was to enter hospital. This was the third time, and Dad said she was getting so much weaker. I was never told outright but the hospital, I feel, knew they had done all that was possible and time would tell. Mum went home but she was spending a lot more time in bed. The chemotherapy was making her feel so bad, it was plain to see that she would not be taking back her position at

work, it was so sad. After a short time the doctors decided that Mum needed to be taken into hospital because she was so ill. This was in Aylesbury, Buckinghamshire. Dad used to visit her in all the free time he had, but with his work this was limited. Edie and I had moved away by this time and with few friends, Mum didn't have a lot of others calling in to see her. Dad used to say that his stay often had to be cut short because a lot of the time Mum couldn't take it.

Jean was still at school and never seemed to get interested in anything. All she wanted to do was go out with friends and never wanted to help in the home. She had always been protected from the worry that Mum and Dad had had over the years. Edie and I had been more involved and I feel now that Jean should have been made more aware of life, then perhaps her problems would not have been so great. Mum always let Jean get away with things. We had jobs to do but not her. Saying this, I was the worst offender without knowing it. As a little girl I had done everything to make Jean happy and secure. She had such a bad start in the beginning, I suppose that was my reason for being this way with her. We did her no favours and this has become quite plain as time has passed. Even now, at the age of fifty-three, her life is in turmoil and she is incapable of any kind of relationship, only with me. It's all so sad.

Jean had always been difficult, but because she was the youngest she seemed to think "I can get away it", whatever the case may be. Thinking back, I tended to

shield her from most people and things that could upset her. Edie at times tried to check her by slapping her, but I couldn't let that happen and in turn this hurt Edie a lot, I realise that now. Jean had a very sad start in life, perhaps this was the answer to it all, and to the life that followed. She wouldn't go to school and Mum found this out. Whoever told her must have seen Jean around when she should have been attending school. As Jean grew up, she had the chance to do hairdressing but yet again, she never ended up going to work. It must have been going on for some time, but because we were all at work we didn't know about this either until the salon owner came to ask about her absence. Mum couldn't put up with things as she had done in the past, and felt she had no choice but to put Jean back into care. I think Mum always blamed herself for this, but we all knew that she had done all she could for her. The next move was to contact Miss Tunley.

Miss Tunley decided that she would place Jean as a live-in nanny in Aylesbury, Buckinghamshire, with a family called Lewis. There she looked after three small children and this, Miss Tunley thought, would curb her past behaviour. I used to travel to see her on her half-days off, but even there she was unsettled, telling me they were cruel and had hit her at times. So instead of enjoying my visit, I used to come home upset as there was nothing I could do, or so I thought. I always believed her, although a long time later, I was to find out things were not quite as Jean had told me. Again, I only saw Jean's side of things. I was unaware that my heart was ruling my head where she was concerned,

and she knew it, I realise that now. It's so sad to have to admit it but that is the truth of the matter.

Jean was allowed to come and stay weekends with Mick and me. This particular Sunday, when it was time to go back, she became very upset. I know I did wrong taking her out of the care of the Council, but I was desperate to make her life better. I felt that things had never gone right for her. Why? I had often asked myself this. I just could not see that these problems were of her own making. Even living with Edie she rebelled against any form of discipline. Edie said one thing, Jean did the opposite. I never told Dad about it as he had a lot of worry about Mum's health, and I felt Jean should have known better than to be causing more worry for us all. She was being selfish and acting like a spoilt little brat, anything to get her own way. For too long she had behaved this way and I felt it would be a big task to put her on the right road. How right those thoughts were!

Jean never changed despite all the help that was given to her, she just carried on. At least Mum didn't have the worry of her any more and she was never told anything. She would have been so disappointed in Jean if she had known, and I couldn't bear the thought of that.

CHAPTER
THIRTEEN

Moving to Kent was to be the first time I'd be away from Mum. The choice to go wasn't an easy one because of her health. Each part of the treatment, Dad told me, made her weaker. Why did God let this happen to a lovely lady like Mum? She took nothing from anyone but gave all of herself. I felt life had not been fair to her, and now I was leaving. No wonder she felt the way she did towards me. I had very mixed feelings the day I left. Part of me felt relief, as things had not been easy once I had told them that I had made up my mind to go. Part of me felt disloyal and I had that same dreadful feeling I had had the day Edie left home — perhaps, thinking back, that's what Mum was feeling. Right then I felt guilt at leaving these two people who had done so much for us all. Nothing is that black and white. Some may feel "why go, then?" There are so many reasons when people leave home. I just knew that this was what I needed to do. It was time for me to stand on my own two feet. I didn't have bad feelings about Mum and Dad, but I know they did about me and this was sad. I didn't know it then but it would be a long time before I would see them both again. All the things that we had done together were going on in my

mind. Why did it have to be this way? Mum looked at me in a cold way, not at all her usual self. I kept hoping that she and Dad would make it all right before I went but they didn't. I now think perhaps I was asking too much from them both. I wanted to tell them so much, but at that time as I left, I just said goodbye and the door closed.

I made my way to the station but I was a pretty mixed up person inside. Mick met me there and then we got the train towards London. We didn't talk that much, I think he knew things had not been easy for me at home for some time, but then it hadn't been easy for Mum and Dad either. It was up to me now. I felt things were not going to be that easy living at his mother's but I felt I had to give it a try. It was up to me now if we wanted to be together, and with Mick studying in London this was the only way. I put my mind to thinking about a job and at this time I had no idea what I would end up doing. Arriving at London we crossed over and took the train to Sevenoaks in Kent.

I had met Mick's mother only a couple of times and I knew from the start that she was not impressed with her son's choice. I never made a big thing of it as this would not have helped any one of us, but I knew that it would not be easy by any means. She was neat as a new pin and the cottage was the same. I had been brought up in a neat and tidy home too, but with one difference, my home had love. The cottage was a cottage, not a home. Something was lacking, I think it was partly due to the fact that his mother was widowed at forty and brought his sister, who was now eight, up on her own.

Mick's sister was not an easy child for his mother to cope with, and needed or rather demanded her mother's full attention. Christine let everyone know, "Don't touch, it's mine". There were fifteen years between them and my goodness it showed. I felt that I had to take one day at a time and hope that she would grow to accept me into the family. I didn't think this would be easy by any means or that she would accept the fact that her son had love for another woman other than herself. A different kind of love, nevertheless I was a threat to her, that's how she saw it. She made it quite plain to me as each day passed by that she didn't like me, and was under great sufferance by having me there in her home.

I must say that I was getting more and more tight inside. There was nothing I could do to change this situation, whatever I did was frowned upon. Some of the things she did suggested a person whose mind wasn't right at all. I don't know how anyone can treat another person with such venom. One may say, talk it out together as adults should, but we all know in our hearts that this isn't always possible, especially if the other person won't talk to you in the first place. There just wasn't any conversation at all. It was as though I didn't exist. Perhaps she hoped that I may just take so much and then give in and go away — this was not to be. If I was to make a life for us both then running away was not the answer. I had done this years before as a little girl. Now as a woman I was damned sure going to fight this thing before it could come to that.

78

I got a job in electronics at Dunton Green near London. I was so glad to be able to go out each morning and be free for a time away from it all. Once on the train I felt free to be myself, well almost. Most of the journey to work, my thoughts were that I lodged at the cottage. Sandwiches were made for me and left on the table. As I picked them up that very morning my call was, as always, unanswered. Mick was away studying in London all week and when he did come to his home he must have felt awful about the way his mother was. I felt that he should do something about it all but times were very different in the 1950s, one didn't say anything out of place to one's parents, it just wasn't done.

I was told one time, to my total surprise, "For God's sake give me time on my own with my own son." I knew it wasn't my home at all but her house and that was how it always was. In a strange sort of way now I can understand the position better, not that I can forget the way she behaved towards me, but she was a widow at forty, with a young child to look after, and her son then called up to the army. In a short time two people she loved were taken from her and I feel it was harsh to cope on her own. One day she actually told me in a fit of rage that she was expecting to have her son back after the three years but "then you came along".

Things got worse as each day passed. She didn't like the idea of me being engaged to her son and I was permanently on my guard not to upset anyone. I took to walking in the park nearby, just walking and thinking things over in my mind. I was becoming a very lonely

and disturbed person inside. It was on one of these walks that I decided that things couldn't go on as they were and something had to be done. The last six months had been a nightmare and with no sign of a home and a landlady to take me in, only I could put a stop to this. After all, I was the one who was feeling ill and dreading each new day. I decided to break off my engagement and go home to Buckinghamshire and see Mum and Dad. A warm feeling came over me, like when I was a kid, and this load that I had felt for such a long time seemed to lift. I didn't want to hurt Mick but how could it work for us both with things the way they were at his mother's home? Yes, I thought, someone has to make this move and it must be me. I decided to leave a letter for him on his next weekend at home. Although I would be there, I felt I could write what it would have been difficult to say under the circumstances. We never had the chance to be alone, so this was the only way without causing a misunderstanding in an already bad situation.

The weekend came. It was no better than all the other weekends before. I decided I would wait until the Monday, just as I was about to go off to catch my train for work, and let Mick know that there was a letter left on my pillow for him. I had also taken off my engagement ring and left it with the letter. He had to catch a later train back to where he was now working. This way, I felt, would stop any clashes by keeping it between us two. I feel bad to admit it but I felt a sense of relief, also a sadness that I was hurting a person who

was so kind in every way, but I felt glad to be out of it all and could now go ahead with my own plans.

I had not reached the station road when he had caught up with me. I could see that he was as upset as I felt. We talked and Mick said, "Hang in there, I will do all that I can to find a place to stay for you." We both knew this would be no easy task, there just weren't the places then like there are today. Life itself was so different, lodgers were few and far between, as most people stayed at home until they decided to get married. I couldn't say no to him, but made quite sure that he understood I would be moving with or without him. I could not live this way.

"Well, put the ring back on at least," he said. I could see how upset he felt by the look on his face. I said yes I would but felt that I had got nowhere after all.

Mick's mother was very offhand when I arrived home that evening from work. She was never ready to speak anyway but I could tell by her movements that she was in a bad frame of mind. I made a point of staying out of any position that could make matters worse. I knew why she was taking this sort of manner, her movements said it all. I just kept thinking that with luck I would soon be away from it all. No point in asking what was wrong, that hadn't worked before, so I played it cool — living in Kent would soon be a thing of the past, I hoped.

My work and seeing Mick at weekends kept me going. His mother always said we were selfish if we didn't take his young sister with us on our walks, but now we just went out and took her moods as they

came. What was the point any more — it was while walking that we decided to get married. We knew we had no chance of a white wedding, money was tight all round. We would make the date for the 24th of August 1957. In that time we felt things would come right for us as regards a place to live in Berkshire. Mick's mother disliked the fact that I had come from the background I had, but I had learned years ago what Mum always told us — we were as good as the next one. I didn't have a problem with it, his mother did. Let her sort that one out in her own head because I realised as I got older some people will never change no matter what is said.

Mick and his sister were never able to talk to their mother in a close way. She was not at all an approachable person. They knew this anyway, no closeness in any form, yet she was overpowering in their lives to a point that stopped her being talked with, as I could with my Mum and Dad. We had our upsets in our home, but they were always talked over and made right. These two were never allowed to voice an opinion, it was all so sad. Contact with her was virtually nil. I realised it must have always been what she wanted, not what they thought about things in their lives, and they had accepted it because they knew no other way. What a selfish person and she didn't even realise what she had done to them both! How Mick became such a kind and loving person I shall never know, but I would like to think I played a part in it.

CHAPTER
FOURTEEN

It was a very quiet wedding. Like Edie, I got married in a registry office. We had two witnesses, no flowers and I carried my Bible. It probably sounds very odd if you compare it to a wedding of today, but Mick and I were broke but very happy just to be together — things had not been easy for anyone, but you cope because you have to. We were the lucky ones, we had two rooms to go to in Didcot, Oxfordshire, and I knew that once we got there it would all work out OK because we would make it work. We would both have jobs, not that we could save anything but being independent was most important to us. We realised that lodgings weren't the best of things and we looked forward to the time when we would get a home of our own. It would come, I was sure of that, and with a lot of overtime we would pay our way and look at life in a positive way.

Dad kept us informed on Mum's health and we always let Jean know that we were thinking of her. We used to visit Jean often. She was still in Miss Tunley's care although she was with a new family now. She was still unsettled and unhappy. I should have seen it then that she would not conform to anything or anybody again.

Living in Harwell village not far from Abingdon was one of the happiest times for us all. The place where we lived gave off the same warmth that the cottage in Tingewick did. Being in lodgings hadn't been good at all, but better than living in Kent. Mick and I couldn't afford a home of our own, so we decided to go for a mobile home. After weeks of trudging and biking everywhere, we found a site at a little village called Harwell. It was a very small 18ft caravan and we were lucky to get it as others were after the same one. We were so glad to get the offer and to our last penny we got our own home. At last we could live our life our way. It was like a load had been taken from us. The day we moved in was a great feeling. We were having our first child by now and on 18 September 1959 our son David was born. A wonderful little boy. Each day was wonderful. The summer of that year was a happy time, each day up bright and early, I would walk miles with David in his pram. Some days we would meet Mick for a packed lunch and David loved these walks, he was such a happy little boy. I used to talk to him right from the start as though he understood my every word.

Mick wasn't earning a big wage and we found it a struggle to pay our way but we did. We both dreaded pay day, knowing it was the same worry every week. Our income was £8 a week and we had the payments to find each month for the caravan. We kept our fingers crossed each week that a bit of overtime would come his way to keep going. Times were hard and I was often glad we had the allotment to grow our own veg, it helped us. At least we always had plenty of vegetables. I

don't want it to sound as though we were the only ones to be in this position. We had friends near to us that were just the same and people didn't have a thought that perhaps others were better off than themselves, it just didn't enter our heads. In those times people never expected help of any kind. How could you ask for help when nobody had it to give you anyway? Try telling that to some of them now and watch the reaction you would get!

Cars were few on the road, buses were most people's transport or we went on foot. It never bothered me walking, as I knew David enjoyed it so much. Only having a small plot of land where the caravan stood didn't give him a lot of freedom. He was growing up fast. We were always in sight of each other. I had no choice in such a small space but with the gate locked and on the days we did stay at home, he had great fun. We have always had a very strong bond, David and I, and it's the same today. We are great friends and I am very glad to have my son grow into a very nice adult.

David always talks fondly about his childhood and can remember so many happy times, like the walks through the orchards in Harwell, and the time that his Dad put him high on his shoulders when his little legs got tired of walking. I remember a time when he was unhappy and then the freedom he felt made him able to cope with things that arose when he reached school age. Mind you, I always made sure he knew that he could talk over anything that was on his mind with us. He has told us many times that this made him feel very open and his relationship with his Dad and me was a

very sound one. The bond today is just the same as when he was a child. I think I was a very protective Mum, not always what he would have wanted I am sure, but fairness was a must with me. Not that people liked to be told when they were being unjust, not only my family but anyone. It always got me cross and I let them know it. Too many cast the first stone and others follow. I had lived with this for many years and I was not about to be one of the offenders, not ever.

We felt very happy and lived life to the full. Every moment was so special. Our walks, tea parties for the kiddies, chocolate cake and milk after school. In a way, my children were brought up the way Mum did us girls when we were small. Mick had lots of time then, it seemed, making toys for them, even a sledge to take them out to enjoy the snow we had. Bonfire nights were great, my kitchen windows were a serving hatch. Jacket potatoes and hotdogs were shared by everyone. The food made up for the lack of fireworks, we had a few as they cost so much, but I know the children enjoyed it all. Both David and Vanessa can remember these happy years at Harwell village. We had never been well off but what we did have we made the most of and we felt rich — with such a family, who could want more?

CHAPTER
FIFTEEN

David was two years old and we were still living in the caravan. I can remember it was a Friday tea time when Dad arrived. He looked very sad and I can say now that I knew something was not right, as he was usually ready with a smile for me.

"Things are really bad for your Mum," he said to us both. He just came right out with it. "Evelyn, will you come and look after your mother, she is on her own most of the time and I have to work. Sometimes she has no-one with her all day, just lying in bed feeling so ill."

My heart sank and I've got to admit my thoughts went straight to Mick. I know it will sound awful but that's the truth. How would he cope without me around? Thinking about it now makes me feel ashamed of myself. How could I even have had such a thought in the first place, my Mum so very ill? I was so selfish to think such a thing. My answer to Dad was, "Don't worry, of course I will."

I can't remember if we had anything to eat or not but I can remember getting David's things together with a very empty feeling inside. I can't help feeling, even as I write this, that I had no right to be so selfish. Dad never knew how I was feeling, I never showed it and once my

mind got over the suddenness of it all I knew where I should be. We said goodbye to Mick and with David in my arms, I got into Dad's small car. Dad looked so relieved as I waved goodbye. My thoughts went to my Mum and I cried as Dad drove along. They never asked anything from anyone and I knew things must be bad for my Mum for him to have come to me in the first place.

I really didn't know what I would find when I got to Dad's house. He hadn't said a great deal except that Mum was a lot worse and needed my help. There was no-one to call on during the day as Mum and Dad had always kept to themselves. Neighbours never called to the house but I can't blame them as they were never invited round. He did say that Mum was very weak indeed and that things had got a lot worse for her. All those times in hospital and all those operations, poor Mum. I felt so unhappy thinking about her just lying there on her own. She was the last person who should be going though all this pain. We got to the house, Dad had shared his worry and looked a bit more like his old self. David was fine, a good little boy. As for me, well, I can't describe how I felt as I walked into the house, I really can't. I can tell you that I wanted to cuddle my Mum and take away her hurt.

It had been eight years since her first operation. Now here she was still beating all the odds by keeping going. Weak as Mum was, she still never complained. As I walked into her room she looked so frail. I held her tight, funny how I had never felt this close in all those years of her bringing us up. This hug said it all. I shall

always remember this feeling. Any doubts about my childhood left me. Mum opened up her heart to me that night. Things she told me had never been told to anyone else. This very private lady, my Mum, needed me to be with her and needed to talk to me about so many things which she held in her heart — her life with Dad, her hopes, her fears for us all.

She had never been a person who wished to discuss personal things. Now here we were the two of us, sharing her innermost feelings. Still to this day I am the privileged one. As I held her close she whispered, "You're a good girl, Evelyn." This may not mean much to any of you, but to me it was everything. I couldn't understand the reasons behind them. She had never found it easy to show a great deal of emotion but Mum loved us three girls like we were her own.

Mum's needs became more than we could give her at home. Help from the hospital was needed and she knew this herself. Eight long months Mum stayed at the hospital in Aylesbury. People in the beds next to hers came and went. One lady and Mum had decided they would get out of the hospital together. This was her aim. Mum went downhill the day the other lady left. I feel that everyone has the right to their dignity and that when all their hopes have gone, everything else goes with it.

One Sunday in April 1961, David and his Daddy were peeking in at the window and Mum was lying in bed. She hardly spoke these days. Mick was hopeful that she could see David, his little legs running across the grass. I feel she did see him, she never said, but I

am sure she did. Pink hyacinths were by her bed. I love their smell, even today. When I smell them I think of Mum. I didn't know it then but the last thing my Mum would ever say to me was, "Look after your teeth, clean them." This upset me at the time, but not now. I realise why we girls had great teeth and I think she was proud of this fact — strange to you but not to me, I can't expect you all to understand. As we left the ward, Dad said he needed a word with the Sister. I understood his need to be private about it. He was very quiet on the way back, in a world of his own. I didn't ask a thing. I don't think I needed to be told anyway, as I felt it inside myself.

The following morning we had a phone call to tell us Mum had passed away in the early hours of the morning, at 2.25 am. I didn't take it in. So many thoughts were with me. My sisters, how would I be able to tell them? Dad must be in a bad way. Uppermost in my thoughts was the feeling that Mum was out of pain now. She had been so brave about it, and I just sat and sobbed for everyone. I think I rang Edie and she was in a state of shock. Bob took the phone from her. It was all so awful. Nobody can prepare you for something like this. I asked Edie and Bob to let Jean know about Mum, as they both lived in Suffolk and Jean wasn't on the phone. They had not seen Mum for a time and this made it so much harder for them. All I could think of was that I had spoken to Mum for the last time at the hospital and hadn't known it then. I contacted Dad, who said he was dealing with all the arrangements and he wouldn't need help as his niece Margaret was

helping him. Mick and I couldn't understand him. We felt sad that he was behaving in such a strange way. We had always been there for him, but now he had turned so odd about everything.

Edie and Bob came from Suffolk but Jean wasn't with them. Edie had decided not to tell Jean about Mum until they went back home. I told them both that it was all wrong what they had done, but they said it was best this way for Jean. I have been told so many times by Jean that she would never forgive them for preventing her from saying her last goodbye to Mum. Even with three children she would have made it down, but it couldn't be put right and never will be.

CHAPTER
SIXTEEN

I had miscarried twice by the time David was two years of age and, at last, in 1966, Vanessa was born after treatment with hormone therapy. She was a beautiful baby and as she grew up, what a happy little girl. Blonde hair and big blue eyes. I know Mick and I spoiled her and, like David, she was a very wanted baby. The first sounds that came from her mouth were musical and she was such a loving child. I was always sad that my foster mother never had the pleasure to hold Vanessa as she did with David.

Although there is a seven-year age gap between our children, they were always very secure. Whereas we three sisters, despite being close in age, were not. My children always knew that someone special was there for them, whereas we looked to each other. Life is so strange. I've always felt it should have been the other way round for us, someone to look out for, with the worries that life brings along. It made me a much stronger person knowing that things depended on my own decision and how I got around this, with as little fuss as possible. It worked most times.

David is like his Dad — they are very dependable people, loving and kind but they prefer to keep the

tactile side of things out of the way of others. Fair play and logic are the men in our life, and I admire this in the both of them. Vanessa is very like myself, has to make sure that everyone is OK and rather overprotective when it comes to the family. She gives too much of herself to others, whereas David keeps some back for himself.

You can't make the whole world love each other. I've been told that so many times by Mick, and by golly how right he is. Life at Harwell village is a long way from our life today. We would still be there if it were up to the children but a new house, much bigger, and the chance for David and Vanessa to have more experience of life around Oxfordshire, living in the town, made up our minds. I feel it was a good and wise move although Vanessa says she feels part of Harwell is still with her. I understand, because there is still such a lot of the cottage at Tingewick in me — she's a chip off the old block, I feel. When we get together I feel the love from her, and she never hides the feelings she feels for us all. I just wish things had turned out better for her in her life.

Jean lives alone now in a flat that is small but very nice inside. Who knows, maybe this is the right way for her, maybe peace of mind is what she has been looking for. Jean didn't get it as a child, she didn't get it in her marriage and very little in her family. Lots of things were taken from her, but one thing can never be taken away, she is a great mother and still stands by her girls in every way. My one wish for her is that my daughter Vanessa will give her Aunty her support always.

This year, on the 24th of August, Mick and I will have been married 37 years. It doesn't seem that long and I wonder where those years have gone. The main thing is we know what a great life we have together; two children and six grandchildren, who are happy with their lives. Nobody has come up with a blueprint of how to bring up one's family, but I feel that if your children see you as their friend as well as a parent, and are given lots of love when they are hurting inside, this makes a very strong bond from the beginning. You can't learn this feeling, you have it inside and not everyone is lucky enough to be given it.

At the beginning of our marriage, Mick was very possessive. I found this very hard to accept, and I made it clear that no-one owns anyone and also everyone needs space to grow in. It took quite a time before he could accept this. I had always had to take care of myself and in turn it made me a very determined and strong-minded person. I am quite impulsive, Mick is not so, he's as solid as a rock, devoted to his family. He is steady-going and he has our full respect. Since being with him I have never felt the need for more than I have already got. When things have hurt me he's always been there to pick me up.

I know if I had spent my time with anyone else it would not have worked. We don't always agree. I think of something that I feel is a good idea, but it takes quite a time, if at all, for Mick to see the point of it. I leave it as I know there would be no point in pushing it. At a later date he sees it differently!

I've always been a very outgoing person. Mick hates going out a lot and in past years I could never understand why, but that's the way he is and, if I decide to go somewhere, I just go. In the past I used to take it personally that he wouldn't join me to visit, or stay at friends' homes. It became quite stressful in the past so I decided to accept it. The answer to the question "Where's Mick?" has changed. I used to say he had a bad head or wasn't well. Now I say "He didn't wish to come" and the pressure on me goes away. People used to look quite shocked to hear the truth. I really should have said it right at the beginning.

Christmas time is a joy at one or the other's homes every year, but I always get to cook the turkey and always make the Christmas puddings, thanks to my Mum's teaching when I was young. The finance side of things were fine up to a couple of years ago and I was able to buy the grandchildren things they needed, and to help out. Then redundancy hit us all and with only one wage we had to cut back a lot. We are luckier than some, we have always saved, our heads are always above the water, but when my wage was no more, that was that as regards big shopping days. Money has never been our main thing, as long as we could cope we were fine. Even now, with money in my purse, it hasn't changed me in any way.

We have a very free kind of life. We don't expect each other to do what they prefer not to. We have dinner when we decide what we fancy, and only have ourselves to please, now the children have their own homes and families.

CHAPTER
SEVENTEEN

Sometimes, not often, I think back and wonder what we gained, if anything, by finding our lost family at 460 London Road, High Wycombe. Helen, my blood mother's first daughter, was very excited when she saw me standing there, but I wonder if it was because she had been leading such a shallow life and something had come along to spice it up for her. There I was, finding out a most important thing in my life, and I realise now that it didn't mean the same to her at all. I needed to know how to fit the faces to the stories that I had been told as a child by Edie so many years ago. Of course nobody would expect hugs and kisses and that everything would fall into place just like that. It was our mother's first family. We three came from the second husband, and I even have my doubts about that. I am and always have been different from the other two, not only in looks but also in our approach and outlook on life.

The first, and it was to be the only, time we all met at 460, Chas the elder son just didn't want to know, we seemed an embarrassment to him. Perhaps he felt guilt about our and his past life. He seemed to relate more to Edie than anyone else. I think it was because she was so

96

like our real mother, in looks and stature. Also, Edie was living in Suffolk and so was he, but had not known she was there until now. His wife came with him, but she would not speak at all. We were trespassing and she let me know it, her face said it all. I did try but failed miserably and decided to give up talking to her. I really didn't need this and wasn't going to take it.

Helen was a mass of chatter but saying nothing of importance. I wanted information about the life that I felt then had passed us by, but for her it just seemed to be a chance to get everyone she could into her house. I didn't know it then, but none of them had been together like this for around eleven years. They just had not bothered with one another at all.

Patrick looked like Jean and he was the most friendly, but then he was the younger of the boys and would have been around fifteen when our mother had died. Maybe he didn't have any guilt feelings about what had happened to the three little girls that had once been part of a large family. In those days what could a teenager have done to help? It was 1942 and we were by all accounts a very poor family. When mother had gone, their world and ours fell apart. I was told they were never close, that they broke away and led their own lives. Our father must have decided to have us taken into a home. No-one wanted to talk about this part of it and when I asked Helen she avoided the question. They just said they were never told where we had gone. I can't judge them, but I feel perhaps they never took the time to find out. In any case, I've written

about how close Edie, Jean and I were — that's a gift in itself and one they surely didn't have.

Years later, Mick and I had an invitation to call and see Pat and his family. In the beginning they were fine and everyone got on well, in fact Val his wife seemed so pleased that we were homely, as I feel sure this was a feeling they had never felt for the others in their family. They were not close and that's for sure. Our children and their two got on fine and I had a good feeling about the relationship. Val liked Mick and for the first time in my life I had a warm feeling towards someone other than Mick and the sisters and Mum and Dad that I grew up with. It was a step in the right direction. The brothers Edie had talked of had now become reality and I felt good. The visits to our home were just as good and everyone felt at ease. This went on for quite a long time. Patrick couldn't give any extra information about our background. This I expected, but he told us a lot about his own. It was during one of his open moments that I realised he and the others hadn't had a good time, that Pat fended for himself when his mother had gone, and all that Helen had said about being the one to keep them together was not so. They had to make their way in life on their own and this had made Patrick a very determined person. Life had been rough for him and he still had a chip on his shoulder which I feel sure he will have to this day.

One day when we called, things were uptight and it wasn't a very nice feeling at all. We didn't need this and shortened our visit somewhat. Both of us felt it and understood when the move was made to leave. We did

try again at a later date. Arrangements had been made long before that. They would be coming for tea on this certain Sunday and as always, I prepared my usual spread. Sunday when we were all together with our children was always special. We waited and in the end Mick rang, thinking no answer would mean they were on their way, but no, Val answered and when asked about tea, stated that no they had not made plans with us, and that Edie and Bob were with them, so we had made the mistake in the first place. Mick said no way and he was very cross about the whole thing. He felt we were being used and I felt so sad because he was right.

The time passed and I was told that Helen had died. Of course I felt sad, as I would about anyone who had been ill and then passed away. I rang Val, I didn't want to, mind you. I intended to send flowers. She did say we would be told more, which would have let me do what I had wished to do from us in Oxfordshire. I was snapped at with "We have just come back from the church and anyway we have got Edie and Bob here, at least they came." I was taken aback! No, I had not intended going to the church, I had already made up my mind about that. Mick and I felt it best not to. I only met Helen for two visits at the very beginning and I didn't feel a great loss. I felt that to go and make a big thing now was not right for me. If others couldn't or wouldn't understand this, then they must deal with it. I never loved Helen, how could I? I never knew her, but I loved my two sisters dearly and always would. Only Mick understood that I did it my own. The fair way as I see it.

They faded out of our life again, their choice. They were in our lives because I had felt the need to fill in the dark spaces in my mind. Perhaps they were never meant to be there in the first place, who knows. Maybe one should leave well alone, but it left me with the certain knowledge that they were never really part of us three little girls from the beginning.

I must take some time now to describe Edie's life. Edie never had time for herself from the very beginning. Being the eldest she always felt that it was up to her to make things right for us other two, me to begin with, then Jean, when we were eventually all together. As I have said, Jean was never easy but that was due to her fear when she was taken from us at so young an age and it never left her, I'm sure of this. Who knows what went on in her mind, we all see life differently. I saw life very differently from Edie in more ways than one, and in Jean's case I was very protective. I'm not making excuses for her, it's how it was but at the time I felt this was the right thing to do. Edie on the other hand felt Jean was out to get attention and got so mad about this. I didn't agree, but Edie was right and it's taken me years to see that.

As Edie grew into a teenager she showed more concern if things made me unhappy. To me she was strong but under that stern exterior there was a softness that she kept hidden and she seemed to be always on the defensive. It was years later, we were both married by now, when she opened up her heart to me one day, to say that she knew I was stronger and more stable-minded than she was. I remember it so well. She

and her family were staying with us at the time for a break away from Suffolk. We had been chatting, Edie went very quiet and looked upset. Nothing that I knew of had upset her. We could talk most things over, always had. I thought that we should go to my bedroom and talk away from the family. Edie was still tearful. She said she had been watching my little girl Vanessa, playing and always singing. This was the cause of Edie's distress. She said her little girl Caroline was sulky and that she had no friends. Of course this bothered Edie a lot and I understand that it would have done.

"Why isn't she like Vanessa?" she asked. "People don't like her and she won't mix with anyone."

I had no answer for her on that one. Caroline had been very spoilt by them both, but how could I tell my sister that without making the matter worse? The next words hurt.

"I've always been jealous of you, Eve."

I wasn't mad with her, there was no point. I told her she had always been my inspiration as I grew up and I had always admired her greatly. I gave her a hug and we sat that way for a while. The subject was never spoken of again.

No-one can really know what a loss one feels when someone you love and have grown up with dies. Each day Edie comes into my thoughts. Instead of the loss getting fainter it has gotten stronger. People say it fades but for me it hasn't. I even feel she is still here sometimes and people think I still have two sisters with me. The pretty young 18-year-old face, the way she laughed, is still so clear and it brings a warmness back

that I felt was lost forever when she went. I think of the mother and wife that she was and the hard life that she had compared with my own, the spondylitis that had affected her since the age of 27 and how cross she would get if help was offered to her. I feel she was really mad at this awful complaint that tried to hold her back. Yet she always found a way to do the jobs that had to be done.

I've always admired my eldest sister. She never really knew this. So many times I would try to tell her in so many ways. It was as if she was not able to take my word, due to the hard life that she had put up with for so long, from every direction. When I lay on her bed beside her in the hospital room, I held her and told her gently again and again that I loved her so much. Edie held me so tight, as tight as she could. I didn't want to ever let go. I was not to know that it would be the last time that I would be able to tell my sister how much I cared for her. As I left the hospital that day, these were to be my last words to her. No, I can't believe it today and I still feel it will never fade. That special bond will stay with me always and the last time spent with her was like when we were two kiddies so long ago in the home. She comforted me when I was small and the roles were reversed at the hospital. The church helped me long ago when I needed help, and when the time comes, I shall see Edie again, this I do believe.

Thinking back, I really wish that the blanks in my life could just go away and a light fill in all the spaces. I would have liked to have known my real mother. I can never say I was held by her, I don't know this for sure.

I can only picture her from one photo. I think of Edie and feel she would have been just like her had Edie been here today. I have always felt that our mother was fragile and a very put-on little lady, that's what her photo said to me, but having met the others in the family, though only for a short time, she must have had fire in her as we three girls did. Was it from birth, or put there by life in the home? I know I shall never really know the answers to these questions. Jean doesn't bother to ask, so why do I still feel this need to know?

POSTSCRIPT

Early January. Mick had been complaining of bad back pain low down in the lumbar part of his back. The painkillers he had taken didn't touch it at all and he got to a stage where even to stand up for a few minutes was getting more and more painful. I made an appointment for him to see a doctor, as he kept saying, "it will go off". After three weeks of this I knew he needed more advice. The first doctor, our family doctor, did not know what the problem was. They thought it was a virus and didn't feel the need for an x-ray or scan. I felt enough was enough. Mick was given tablets to settle his stomach but this didn't help one bit. It was now into the sixth week. Mick was told that a virus could take time to leave the body. We didn't feel at all happy about this. We felt cross as we felt that they really were not sure what the problem was from the beginning. Mick took days off work. Even his boss had noticed that Mick was having trouble at work trying to keep going. Mick looked ill but still he never said a thing to anyone but me.

25th February 1997. Mick was trying to get dressed. He could hardly bend his legs due to the pain. The night before he had trouble holding a cup and I noticed

he spoke in odd sentences. They were not finished off and he had trouble remembering what I had just said to him. "That's it!" I told him, "we are going to see the doctor this second." I didn't ask them for an appointment, I was bringing Mick down. He wasn't in any fit state to drive himself. "Sod the work," I said. It was high time someone sat up and took notice. I felt mad and worried all at the same time. When I had rung the doctor's it was hard to be polite. If they couldn't take my word then, I said, "Put me, this very moment, in touch with our doctor." The receptionist got the message that time. I drove to the surgery. Our doctor saw Mick straight away and said Mick needed to go to the John Radcliffe Hospital and that he would be seen right away. I know he knew there was a problem and he gave me a letter to hand in at the hospital.

Mick received a letter to take to the Radcliffe in Walton Street, Oxford. He was seen almost right away by a top specialist and she suspected a small stroke. We were told at the time that he could go home but within a short time we were asked to go to the Churchill Hospital. I drove Mick there and the next thing he was shown into a ward in which a bed was waiting for him. His doctors had tests that started at 2.30p.m. and went on until 9 o'clock that night, in which time several doctors had seen him. I had made it quite clear from the start that I would not leave Mick at all and, if need be, I would sit in the corridor.

The scan had shown a tumour in the brain and they kept talking about an "abnormality" in the diaphragm so we both felt there was a great deal to worry about.

But no-one would commit themselves. Although right from the start we made it clear that we wanted to be told everything, we knew they were not telling us all, however much we asked them. Mick was told that they intended to do a biopsy on him on the Monday. He was already on a lot of tablets and blood tests were being done all the time. We never did know the need for so many tests. I asked for Mick to come home that weekend and they agreed as he didn't feel ill, but Monday came too quickly. Mick was back in the Churchill Hospital when we were told that no biopsy was needed. The scan had given them all the information they needed.

We still hadn't been told what this "abnormality" was and I had reason to feel that we were being kept in the dark. I felt mad about it and we insisted on speaking to the doctor. They said, "Oh, we thought he had seen you." But of course he hadn't and they knew it. My daughter Vanessa stayed each day until very late and then came back again early in the morning. The doctor still hadn't seen us.

That day he did at last arrive and asked us to go into a small room. My tummy was like a pit and I feel sure that Vanessa and Mick felt the same. The doctor obviously had no idea that we hadn't been told any details and just came right out and said to Mick, "As you know, you have cancer." It was in the brain and kidney and it had spread to the left lung. My daughter's feelings gave way and I heard myself say, "No, he didn't know. None of us did." The strangest thing happened. I felt that I was behind these people, an onlooker into a

very distressing scene. It must have been the horror of it all. I felt myself clinging to Mick and he to me. Radiotherapy took place the following Thursday and Friday. Then steroids. No other treatment could help Mick, we were told.

23rd April. Mick has had five days of steroids which leave him feeling very sick, shaky and very cold. Mick's next appointment is 12th May 1997. We are taking things day by day. From the 25th February, life changed for us all. Since Mick's treatment we both feel it's up to us to make each day as good as possible. After getting down to one steroid every other day for one week, the specialist has said to come off them. That wasn't a good idea at all. Mick has felt awful. He is taking half a steroid each day but the sickness will not give in at all.

1st May. Mick has had quite a good day. It was copable. He seemed brighter into the evening. That's a bonus. We are now both realising that we have let this illness become the centre of our lives. Mick said all the people enquiring by phone only adds to upsetting us both, but people mean well and we have to realise this also. Mick won't answer the phone because he feels the pressure on himself to be what he isn't feeling. We made up our minds, at Mick's request, not to keep talking about it all the time. I've got to the point where I have to think twice how to ask, "How are you feeling today?" We both stay in the house but today I did say, "Let's go out for a drive." Twelve days have passed and

107

we have not left the house. Surely this isn't the way it has to be, but Mick just can't face going out. He feels so ill at times. He says, "Don't ring the hospital or the doctors, they have done all they can." I feel so unable to help and do more and to make things better for Mick.

2nd May. It is very hot. In the eighties I think. No chance of getting Mick outside near the garden as the heat would be too much for him. I don't know if it's the tablets or the radiotherapy that's making Mick feel so bad.

4th May. Mick's woken up with pins and needles. He's only taken half a steroid for the fourth day. Also he's eaten very little. He's feeling so sleepy only two hours after getting up. Mick has fallen asleep again. I've got to keep a good watch on him today due to those strange feelings in his right hand.

One thing I've noticed is that Mick's hair has grown back quite well, fluffy, but that's good for morale although, truthful as he is, that's the least of his worries. I do love him so much and he's not made any fuss and I know he is sick of all this bad feeling brought on by the illness he has.

22nd July. I've been at home with Mick, as I said, that's where I wanted to be, but with an open invitation to join the workforce if and when I felt the time was right. This, I feel, was a very generous move by my employer Paul. Things have been very stressful for Mick and he has been wonderful taking everything that has been

dished out to him. He has never once complained. If the boot was on the other foot I would never have been so brave, but that is the sort of man he is.

July 1997. I felt really poorly. My stomach was in a state. I couldn't think what could be wrong. My eyes during that day were dreadful. My vision was completely blurred. This went on and on and by Thursday I became very worried and rang, hopeful to see the doctor. I was given an appointment for the following Monday 28th July. That day couldn't come quick enough for me. I realised now that I should have pushed for an earlier appointment but that's not always possible. My daughter wanted to take me down, realising that there was something major wrong with me but I insisted I should really wait rather than cause problems for the surgery. I went on the Monday for my appointment. No wonder I felt so ill, even my own doctor said I should have been seen sooner. My sugar level was 28, when normal would be under 6. My urine was full of sugar and protein but was clear of ketones. My doctor had said I may have to go into hospital straight away. I said I couldn't. No way could I leave Mick. My son David rang. He said, "no problem." He would come and live back home with his Dad if it came to that. That took a great weight off my mind I can tell you. Since 28th July I have been on tablets and each day I have been seen by the nurse and the doctor for a check on my problem. That's all Mick and I needed, to be told that I was a diabetic.

16th August 1997. My eyes are still a problem. Still blurred and I have been told they may be the last thing to adjust to tablets and a very strict diet. If I do the right things, the clinic will keep everything else ticking correctly. It's quite common at my age to become diabetic, but both doctor and nurse feel sure that shock brought it on. I just want to get things right and to feel sure of being OK for Mick. I do worry when I'm not in control of the situation and Mick doesn't need any sort of worry with this illness to cope with. I'm very concerned about Mick. His mouth and speech are back as they were at the beginning of his illness, though he says he has no sickness or headaches strangely enough. Since last Thursday something has changed, but we don't know what. I'm all for seeing Dr Tate but he is away this week and Mick's request to leave it until he can see his own doctor must be abided by. It's only three days' time, he said.

We have both been very open with one another about this dreadful illness. It's the only way to be or we wouldn't feel sure of ourselves. It makes us more aware of each other's needs, and sunshine days and days out have a totally different feel about them. It's true — this thing, this bully of a thing, opens up one's heart to the point of breaking. One good thing, I'm OK and under control, and that makes it better for us both and makes us stronger. Part of me wants the 25th August and the test results here and now and another part of me wishes it didn't loom up at all, but we've to face what comes for one another.

September 1997. Mick had been going for check ups to Dr Tate and on 25th September 1997 Mick was to see Dr Talbot at the Churchill to see if these tablets have done their job. At last we reached 25th September. Mick showed by his actions that he was rather uptight which isn't his usual self. I knew it was because he doesn't care or feel sure about this doctor we were going to see. This one has an offhand attitude. Neither of us like him. I felt, if the need arose I would put my word in and that's it!

We arrived a little late at the hospital but it was better for Mick. He was seen right away. A CT scan is needed. Mick has an appointment for Monday 30th September at 8.30 am. It will shed more light on what is going on. Meanwhile, Mick is back on the steroids. Four at night and four in the morning. He has no other option now. Eight months ago there seemed so many avenues open, but one by one they have been used up. We just feel glad we have each other and spend every moment together. We had such sorry and sad news this morning (28th September). We have lost our dear friend Christopher and for the first time Mick has let his feelings go. Not for himself but for others. We hugged each other and it was heartbreaking to see him like this. Christopher's wife Michelle is holding up so well and we must be the same.

Well, Monday is here. Mick has had the scan and has to await the outcome from Dr Rowelle and team. I drove Mick down to see Dr Tate. He feels like Mick does, we are back to square one but we must keep optimistic. It's the only way. All the time Mick is on the

move and feeling as well as can be expected, we must go up and onwards and help each other.

2nd October 1997. We are still waiting to hear back from Dr Rowelle at the Churchill but nothing yet.

3rd October 1997. We went to the service at Blewbury for Christopher's funeral. I thought it would be too much for us both but Mick said he was going. I said I would go but he insisted that we would both go together and this we did. It was very upsetting, but I felt very proud that Mick had made it there. We both came home with heavy hearts. My old friend Diana (Chris's mother-in-law) had said it was a great relief when Chris left peacefully on 27th September. She rang me and we felt their pain as if it was ours. Life is hard but Chris is in God's safe hands now, resting from all his worries and pain.

4th October 1997. Will Mick have news today? By Monday I had decided to ring the Churchill. Dr Rowelle had not seen the scan as yet, but as soon as he had Mick would hear from them. At least something was moving towards his result. He could really do without this stress.

Two whole weeks waiting and, at last, Mick has heard back. Dr Rowelle will see him on 20th October. We shall then be told the result of the CT scan. At this moment Mick has to carry on. Full steroids, six a day, they make his limbs so weak but he has no other choice but to take them.

20th October. They are running very late at the hospital. So many other people in need but one and a half hours later Mick is seen by the doctor. It was Dr Riddle who was very kind and we asked to see the scan results. We felt very sad inside to be told that the tumour on the right side of the brain had caused the second attack to his speech and hands. We had hoped for a lot less, but the steroids have to be taken and reduced over a three-week period. Mick feels weaker than ever before. I do all I can to make things right for him. It's not hard, he's such a good man about it all. On the 28th October we have to see Dr Tate. Maybe by then Mick will be stronger as each day the steroids get less. I pray so much that he will. Going almost into the ninth month, health is the only thing highlighted in our lives. We know it won't go away but I just want things right for Mick.

25th October 1997. The first time since February that Mick could go out. He was determined to see the band "Silent Running" play in Oxford. There were no strings attached. We could cancel arrangements at any time. He liked to go out, I think, and made a special effort to be dressed and ready. At 6.45a.m. he woke me to tell me that he had bad pains in both legs and took some painkillers. He requested no doctor yet. I will heed what the day brings, and if I feel the need I shall call the doctor for help or advice regardless.

Dr Tate is so kind, he is our friend as well as our doctor. He said again to take it day by day. Weakness is really getting bad now and the pains in Mick's legs are

due to his kidney, Dr Tate feels. He felt he had let us both down due to the fact that he couldn't cure Mick. We assured him that he had never let us down and was a dear friend to us both. I can't express my feelings, that Mick has had this kind of man to help him through such a traumatic time.

3rd November 1997. Three days have gone by and Mick is down to three steroids a day with no headaches. That's a good sign. I feel the specialist had reservations about Mick getting to this stage, as we were told to up the tablets if any pain occurred. I have been rather edgy myself today. The past nine months have caught up with me. I am letting my inner feelings out. Should I have done this and said how I felt about so many things? I don't think so but life has changed so much and I need to put our life back into perspective again. I have cut myself off and it's due to the feeling that Mick's needs are all that matter. It's never what I feel like or need to do. I can't say I truly realise this. If I wanted to go and see Vanessa for a while, I wouldn't go because Mick, without knowing how I felt, wouldn't want to go. It's so many things and I've gone along that path because his needs are priority.

I've decided today that this can't go on to the extent that it has been. It's my fault but I will end up mentally ill if I continue to be this way about him — it has to be done on Mick's terms and I find that I go along with everything. This wasn't how I used to cope with things and I must have a say in our life too. Mick doesn't understand what I'm saying but it was hard after we

had talked it over. I'm sad inside but we've always cared about each other's needs and I was catering for one only. It's my fault but each does things their own way to cope with it. I just went a little off line.

6th November. I've not been so protective and it has worked much better. I even left Mick and went to my doctor's appointment alone. He was so pleased to see me when I returned home. You see, I felt I had to be with him all the time in case the need arose, but I've been wrong.

20th November. Mick's had off days; he followed each stage of steroids and is now down to one every five days, but today he says he's going back to two per day. He has had an aura in his left eye and felt dizzy, but feels that perhaps two tablets a day is what is needed. It's his decision and he will have to cope with the weakness they bring. He likes to make a pot of tea but with the weakness he can't do a thing. Mick has always been so much a home man and it does make him stressed, even the fact that he can't go into work. We both know at the moment that's impossible, but we keep positive.

22nd November. I am having to ring Churchill Hospital, and it's Dr Hrouda who must be informed of the increase in steroids. It seems that's all we do, but we do other things also — no rush, just take life as it comes along.

23rd/24th November. Mick's speech has been strange, due to the fact that he doesn't realise this, but I have kept an eye on his movements. Mick needs to use a cane to aid his walking, he's had two days of trying to use his legs to the full. I don't know what's the worst of two evils really, we just try everything we can.

25th November. At 10 o'clock this morning Mick felt faint and just went down to the floor, not fainted but felt sick and strange. His feet had been swollen for three days and I'm wondering if things are happening inside which we wouldn't know of. His speech has been odd for three days now and he is very sleepy today. In between all this an unpleasant call from his mother did not help things at all. She has concern about a move of house and seemed to forget this is not good for any of us. Since this call Mick has seemed not quite himself — sleeping, but I won't contact the family. I don't wish to cause alarm.

1st December. More radiotherapy is needed. Eight doses of the steroids are not doing the job any more. For the first time I'm so unsure this is the only way forward. Now I am worried but can't show it — that won't help Mick if he sees how I really feel.

4th December. Hope it all goes better for Mick. I am very aware it could go the other way. Two treatments later Mick's speech is a little better. The weekend is here, Mick is feeling so weak, we know it's the steroids.

He can't walk upstairs, we do make it up but it's awful for him and now it's too much for him to cope with.

9th December. Radiotherapy again today. It may help Mick due to two days without it, we shall see. This treatment has really taken its toll on Mick, yet he still never complains. His swollen feet and legs are getting him down, he can't get socks on. As he has so often said, the medication and treatment makes one more ill than the illness itself, yet we still go on to preserve life against all odds. You don't break under pressure, you fight.

18th December. Christmas is near. I am lucky to be spending it with such a brave and wonderful man. I would urge everyone to realise the wonder of their own lives from the beginning — but sadly we don't, we are too busy living to give it a thought. Our four-year-old granddaughter never fails to ask, "How is my Grandad?", a little girl, she is a wonder of her own making. She feels it in her heart, I know she does, and that is a special and rare gift.

24th December. Mick is really poorly, we can't make it to Dave and Jan's, it's sad but that's the way it must be.

25th December. Christmas Day. We are still together. I thank God for this. Vanessa went to mass at St Helen's. She and David came Xmas morning. They both realised that this Christmas we can't join them. Tears follow sorrow, but I will make sure that Mick and I

have our lunch even if we don't feel that fussed really. I had cooked the big turkey for them as always, some breast was carved for us. David was Father Christmas, presents were given out of the sacks. I had got things ready for everyone and Vanessa and Mark stayed at our home till 3p.m. We did not expect this and we both wanted them all to have a great Xmas at Dave's house, this they did. We couldn't bear it if the kiddies' day was spoilt. I was still up at midnight. Vanessa had settled her family back at home and brought the Christmas video to show us both. At 3a.m. Vanessa left us for home, she was whacked out, but more contented by doing what made her feel happier, being with her Dad.

Talking with David, I broke down on the phone. I just couldn't help it. Days have passed and Mick seems so much worse. All he can do is lie in bed and sleep. These steroids are evil. All I can do is sit and watch. I am so afraid of what can happen to Mick. I wasn't even getting dressed. David said, "Make up your mind to go out to the shop." I feel he is right and I must do it or I think I will go mad with worry. I took my mobile with me but did not use it. I had to put some trust somewhere into our lives.

When I got back, Vanessa had called to see her Dad and they had watched a film together. We all talked for at least two hours about our life and that evening my heart felt lighter. I felt Mick felt the same as I did. Saturday evening, Mick had tears in his eyes and he told me he hadn't thought he would make it until Christmas. I said, "Well, you showed them, didn't you my love?" I gave him a hug and it was the first time that

Mick had talked so openly about any of it. All this is a great burden on Mick but he still never complains.

Mick said he would like to go to the shop, he really wanted this. He found it very hard to get into the car. I wanted to help him but he insisted on doing things for himself. I find it hard not to help him but I respect his wishes.

31st December. David has done dinner for us all. Mick rested all day and with my help was able to get dressed. We all had a wonderful roast dinner just like it was Christmas. Crackers and carols played. Laughter at last.

1st January 1998. Mick has felt a lot brighter than he has for weeks. We were told that this would be the pattern to this dreadful illness. I'm hoping the months ahead are going to give Mick a break from all this badness. Like the song, each day must be "Oh what a wonderful day". Mick likes that song and I've heard him sing to it at times.

December to March 1998. I will go no further into Mick's diary. The time that followed is private to us both.

My life alone? Well, I feel I need to write this to complete my story. It's June 1998 now. Life has been hollow since the 14th of March 1998. Without Mick, I've been so lost. At last I've started back writing — up

until now I've not wanted to speak to anyone, phone, call, or deal with people, or our home.

Not being very sure of anything, I've been sleeping at my daughter Vanessa's home, on the settee. I can't remember sleeping in a bed, for at least 17 months. I've been assured this is the grieving process, but at times I think I'm going off my head. It's OK for people to say, "ring me", but once that phone is put down you're back to where you were. The sick hollow feeling is with you once more. Does everyone feel like this, I ask myself? No interest in anything or anyone. I dealt with all the letters promptly, that's the only thing in my favour at the moment, dealing with the bank and solicitor, I had to do it and I did!

3rd June 1998. I made up my mind firmly that I must try harder. Mick wouldn't like to see the person who had been strong about everything, so weak. My interest in doing anything is nil. But today, after a good night on the settee in our home, I've been reflecting on so many things. Today may be my turning point. I don't feel bitter or cheated, but sad that Mick can't share the things we used to. Perhaps now I've begun to live with it a little better. Holidays have been mentioned but my feelings go back to Mick and I driving out somewhere, and the sun shining as we drove past pretty places towards our own holidays.

The last time I felt that feeling was when we went to Blenheim Palace. He had such a wonderful day, we both did — it was the smiling day, one of his better days. Mick wanted to go back to Blenheim, the week

before he had died he had said so — we shall, I assured him. On the 21st May David, Vanessa, myself, Steve, Mark (Vanessa's husband) and Mick's friend from work, Peter, went back to Blenheim. Promise kept. We chose a beautiful spot, lake and trees, branches dipping to the grass, and there we sat. We all had our own thoughts and this special place belongs to us all. Swans on the lake reminded me of his pillows the last day in the hospital. I said it then, his pillows crisp and white looked like swans, they really did — that will stay with me forever. Mick, a special man.

I have taken the grandchildren out to the parks that we both enjoyed together, it hurts so much. I get that hollow feeling, even when I try to help myself. How can the little ones understand? So the more I try and hold my feelings in, the stress inside gets worse. David doesn't say very much at all but Vanessa just can't seem to come to any understanding of the loss of her Dad. I've tried so hard to say he could not go on like he was. Mick had said on the Wednesday, "I've had enough, Evie," and I knew it too, but she feels bitter towards everybody and everything. She has changed so much — at war with the world I feel. I'm so in a muddle I must make this day the beginning of what my life can be. I'm sad and things won't ever be the same as before and it will hurt — even the clock chiming brings Mick into my thoughts, he loved that chime. I have even sent off for a new passport, don't ask me why, I've no plans to go anywhere. None of this makes any sense.

The stress of the last 15 months has played a big part regarding Vanessa and me. We were the ones with her

Dad, doing everything for him when things got so bad. There were days when we three were the only ones who really saw what Mick was dealing with and how the three of us stayed so close, held our arms around each other. We don't agree on anything it seems and upset each other most of the time. Strange that the two who did the most caring can't help ourselves clashing — perhaps we both feel we hurt the most, I really don't know any more.

Spending today on my own. Maybe we will appreciate each other more when we do meet up. All I know is that things have got to change for both our sakes.

5th June 1998. I spend the second night at home, I hate it but I realise there are things that only I can do for myself. Up to now I've left the curtains closed, why bother to open them? I felt there was no point. I don't want to even get dressed. Vanessa rang around midnight to see if I was all right. I said I was, but really I had been in a state all day. I had talked with a staff nurse at the hospital. She said all these feelings are part of the hurt we are going through and we think by closing ourselves away the world can't hurt us. She is right, that's just how it has been.

The collection at the crematorium. We all wished it to go to the Abingdon Hospital. The love the nurses gave showed in so many ways, it shone through, and we decided this was what we wanted. Vanessa and I knew it had to be done. It was so stressful as we passed Room 5, but we did feel it would be wrong just to send

the money. The decision on how to use the money was up to them. They need so many things and the very nice sum would help for others' needs in the hospital. Going back made me realise just how wrong it would have been for Mick to still be in there. I feel me being there every moment for that last month kept Mick going on. One staff nurse said we were feeding off one another — I don't know what she meant, I must ask. Maybe I missed something she didn't.

6th June. It's the fourth night I've spent alone, and it was bad. I nearly rang Vanessa but decided not to and when morning came I was so glad I had not rung her.

Sunday 7th June 1998. Aron my grandson decided to stay over. It was so good to have his company, we then decided to have lunch out. He is twelve now and we are able to talk on most everything. I keep thinking that things are getting a bit brighter but I'm still not sure what I expect to happen. What a muddle I'm in!

8th June. I rang the solicitor today. I felt that every letter I received from her just brought back that loss we all feel. I've been dealing with my letters and felt Mick and I were always on top of things. Just get it over with. I felt I had to take firm control to be able to move onwards. My boss had rang me about taking up my position again. I really think I could do this now, but I'm not too sure how I will react to my friends to be honest. The last thing I wanted was to get upset in front of them.

9th June. I decided to call and help Vanessa with the kiddies but shall go home to sleep. I've had a call and said "yes" to working again. My work will need a lot of concentration, this will help me I feel. I still wonder is this the right move but I'm lucky at 60 to be asked and given the chance to continue with my career.

14th June. I made my first visit today, to dear friends I've had for 38 years. I was so pleased that I had made it, driving to their home. I felt a great sense of achievement. Things will be different now from the way I have been living at home for the past year. I may not like it but I'm determined to make it work for me.

30th April 1999. I've changed, working longer at work, made two wedding cakes and made a second visit to my best friends Diana and Harold. Spent the day with them, had lunch and enjoyed looking at Jayne's wedding photos. Diana has retired this weekend and it was a joy to see her face. I had sent a basket, a violet and white arrangement. The room was filled with flowers, it was wonderful. She is a dear person and she deserves the best always. Life has been hard but she still helps others, they both do!

2nd May. Sunshine again. Let's make it a good day. I don't feel the need to write any more. Every day Mick is in my thoughts, that will never change. This home is not the same any more and I know it never will be. Only Mick knows the deep sadness and loss I feel without him — others think they do but they don't and

never will! We have a dear friend Steve. He is my rock since we lost Mick. He phones me daily and calls in almost every day. I know that it is he that has helped me and he loved Mick deeply. You see, all of us hurt so much and I grieve for them also.

My work is going OK. I don't have much go in myself. Vanessa and I are seeing things better now. I don't like going out at all. I would like the sparkle to return in me. I'm a very lost and uninteresting person at the moment. I need to get to grips with myself, not only for me but for others. Time will heal and I'm working on it. You see, Mick had always been gentle and kind to me, he never found fault and always gave me the chance to achieve my dreams — nothing outrageous just being able to live our lives. He loved his work and I mine. We were lucky, not only did we have each other's trust but Mick would never have let anyone hurt me in any way. No-one could know me as he did, no, not ever, and he gave me his love to the very end. We were best friends, you see, and very few can have all these things. Not once in our forty years did he ever hurt me in any way and I could not have asked for more. I really believe he was unable to be unkind to anyone, so you can now realise how great our loss has been. I know he will always know how much he was loved and we had faith in one another always.

12th July. This weekend has been much better for us all. I've had my four grandchildren over two days to stay, it's been fun and a lovely way of getting warmth and comfort. It's made me realise even more the need

125

to see through the sadness in all our lives. The children do know that we have been very unhappy and from little things they have said I know they miss Grandad very much and don't understand why it has happened. Any questions they ask, we tell them the true answers, but it's a lot for the little ones to understand. Danielle spent a lot of time with me in the hospital with her Grandad. She said she was my little helper and made it clear that she wanted to be with her Grandad and help him. She did this with her little face, each day he saw her.

16th July. My work is going well. Got up bright, which is more than can be said for the weather. I slept well and I am going to Ross on Wye Bird Sanctuary. I'm looking forward to it. It is a vast improvement. I feel Mick loved going places, and I do miss him sat by me wherever we were going. He always took the pretty route, it never mattered to us how long it would take, we were enjoying the drive. I just wish that we could have taken to retirement together. This is a lonely road and as I write there is such sadness in my heart. Saturday comes round so fast these days. Steve has invited me to a craft fair in Reading. I am looking forward to going. The weeks come and go and with it my faith is slowly coming back. I'm pleased that it is, as all felt lost at one point. Vanessa did a wonderful meal for us all, we had a nice evening. She is much brighter herself, this made me feel so much better in my heart. Of course, we all get really bad days, dark clouds come and go. It would not be true to fool ourselves that every

day is going to be a good one, as much as I like to dream it could be, but as time goes on I'm told it will heal the hurt and the loss will be more accepted. I can't wait to feel this way.

12th August. Fell asleep, woke at 3a.m., lights all on, TV on. I had left the doors unlocked! I was so pleased, the first night that I had slept and hadn't dreaded it — things are looking up.

3rd September. Long time since I wrote in my diary, working has helped me so much. I have spent weekends with family and friends. I don't wake each morning with sad thoughts. I went to Blenheim Palace on Bank Holiday and placed a white rose beside our tree — it was a warm feeling and I felt so close to Mick. I talked and I know he heard me, I'm sure of this. No tears, just talked. Life went on around me, people, the swans, birds' movement, but I was in a world of my own. It gave great comfort to me, Mick still gives me strength as he always has, no-one knows just how much. I have Vanessa and David, and Steve. They have helped each other and in turn helped us all. Things that I felt were major worries, don't matter to me now. I now see things in a different way. That last day we had together, I stroked his hands and face, and I hope he knew we were all close to him. Mick left something in all of us that day, something we will share forever.

23rd December. I have no interest in decorations but the kiddies are excited and we will have a good

Christmas. Mick would be the first to say "get on with life" well, we are in some strange way but it's not the same. My interest was full at this time of year for so many happy years, let's try and get that feeling back for all our sakes.

18th July 1999. This weekend David has invited me to Waterperry Gardens. I went, and feel more refreshed. I heard the cuckoo this morning and it was great at times like this, all seems brighter. I still have to remind myself each day that we can't change what life gives or takes away. I sometimes wish to hold Mick and feel his touch on my arm, it was his way of saying he loved me and everything was all right. I received a thank-you today from the hospital. It was nice to hear from Brenda, the head of the ward. It seems there are to be cutbacks, wards closed maybe. I really hope not, so many people get love and care there, and at the time in their lives when they really need it. As I've already said, the nursing care given to Mick and others was pure devotion.

16th January 2000. I have been asked to make a wedding cake for my friend's daughter Jayne. I will do this, maybe it will put me back on the road to doing some of the things I haven't been interested in for a long time. I'm also designing the centre piece. Things are getting better. Vanessa is so pleased that I'm doing what I liked most and I'm spending the evening with her and the family. We shall have a meal and talk into the night. Things are easer to talk about without

128

crossness creeping in. The past two years pulled us apart, they should not have but they did. We shall pick up our memories and fill up our hearts and have life together again.

15th February. I haven't written for weeks now, but baking and work have kept me busy. I visit friends at weekends and look around me and see couples at war, bad words to hurt the other, and wish so much that they could realise just how wonderful life can be for them and what they are missing by being at stress with each other. I've got far more understanding these past months and I'm looking at life with new eyes and mind.

15th October 2000. Mick would be 65 today. Yes, I've been weepy and sad for him. The plans we had won't be. No more diary now, but I have needed to let my feelings be known and it's helped me to go forward. I hope my book has been interesting and warming to the heart. I have had great reward in writing *Home Kids* and release in my heart with my diary — the need to write it has been fulfilled.

I live at the wonderful place called Abingdon, by the river. It's a pretty place and we have had many happy times living here. I don't think that I would be happy moving to a different town, not now anyway. Life is so different now, so that's the reason I wish to stay here. My mind hasn't been too settled at all, but I feel that I am getting a lot better than I was. Our family will never be the same, not ever. I know this, but there are many others that are far worse off than we are. Having said

this, it won't ease the pain that we feel and so many things bring back thoughts of our loved ones. It hurts when we realise that these things we all did together can't ever be done as a full family again.

I want all of us to remember these times with love and happiness in our hearts and not let bitterness creep in, no matter how bad we feel about life. I know how hard this can be, but we must keep in our thoughts how lucky we are to have our health and the life we are still living now.

ISIS publish a wide range of books in large print, from fiction to biography. Any suggestions for books you would like to see in large print or audio are always welcome. Please send to the Editorial department at:

ISIS Publishing Ltd.
7 Centremead
Osney Mead
Oxford OX2 0ES
(01865) 250 333

A full list of titles is available free of charge from:
Ulverscroft large print books

(UK)
The Green
Bradgate Road, Anstey
Leicester LE7 7FU
Tel: (0116) 236 4325

(Australia)
P.O Box 953
Crows Nest
NSW 1585
Tel: (02) 9436 2622

(USA)
1881 Ridge Road
P.O Box 1230, West Seneca,
N.Y. 14224-1230
Tel: (716) 674 4270

(Canada)
P.O Box 80038
Burlington
Ontario L7L 6B1
Tel: (905) 637 8734

(New Zealand)
P.O Box 456
Feilding
Tel: (06) 323 6828

Details of **ISIS** complete and unabridged audio books are also available from these offices. Alternatively, contact your local library for details of their collection of **ISIS** large print and unabridged audio books.